Moments to Remember

The Art of Creating Scrapbook Memories

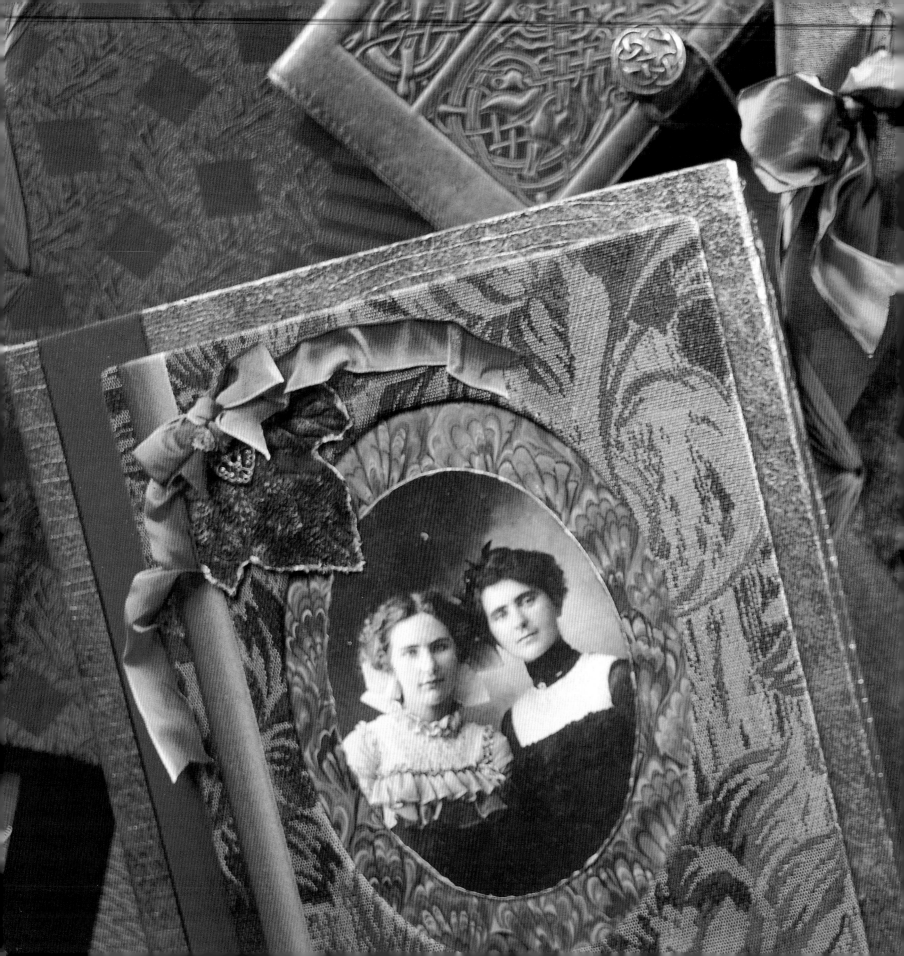

Moments to Remember

The Art of Creating Scrapbook Memories

by
Jo Packham

Andrews McMeel
Publishing

Kansas City

Chapelle Ltd.

Owner: Jo Packham

Editor: Linda Orton

Designers: Sherry Ferrin, Holly Fuller, Amber Hansen, Mary Jo Hiney, Candace Pratt Hoover, Pauline Locke, Rhonda Rainey

Staff: Marie Barber, Ann Bear, Areta Bingham, Kass Burchett, Rebecca Christensen, Marilyn Goff, Shirley Heslop, Holly Hollingsworth, Shawn Hsu, Susan Jorgensen, Barbara Milburn, Ginger Mikkelsen, Karmen Quinney, Leslie Ridenour, Cindy Stoeckl

Photography: Kevin Dilley, photographer for Hazen Photography

Photo Stylists: Leslie Liechty, Jo Packham

Acknowledgments: Ready-to-purchase scrapbooks shown in this book were created by: Books Nouveau, Elements, Molly West Handbound Books, and Schiavone Studios. Cards displayed in this book were designed by Candace Pratt Hoover of Reverie.

www.andrewsmcmeel.com

ISBN: 0-8362-5255-1

98 99 00 01 / KWF 10 9 8 7 6 5 4 3 2 1

Library of Congress Cataloging-in-Publication Data on File

ATTENTION: SCHOOLS AND BUSINESSES

Andrews McMeel books are available at quantity discounts with bulk purchase for educational, business, or sales promotional use. For information, please write to: Special Sales Department, Andrews McMeel Publishing, 4520 Main Street, Kansas City, Missouri 64111.

If you have any questions or comments or would like information about any specialty products featured in this book, please contact:

Chapelle Ltd., Inc., P.O. Box 9252, Ogden, UT 84409
Phone: (801) 621-2777
FAX: (801) 621-2788

The moments, the places, and the souls that I hold most dear are brought back to me in these pages, not unlike the notes of my favorite melodies echoing. They quiet and reassure me when I am weary, and celebrate with me when I am content.

Table of Contents

Introduction 8

Archival-Quality Scrapbooks

Photography—the First Step 14

Buying a Good-Quality Camera • Get in Close • Experiment with Angles • Shooting Outdoors
Catching Real Life • Manipulating Your Photos • Cropping Your Photos • Photo Art
Zooming And Cropping • Hand Tinting

Organizing—the Second Step 26

Organizing a Work Space • Organizing Photographs • Organizing Negatives
Storing Negatives and Photographs

Designing Scrapbooks—the Third Step 29

Scrapbook Covers • Scrapbook Pages

Scrapbook Covers 33

Rose Frame Cover • Faraway Places Cover • Japanese Ribbon Cover

Scrapbook Pages 57

Aged Paper • Leaf and Napkin Scrapbook Page • Gold Leaf-Imprinted Scrapbook Page
Pastel Lace Paper Scrapbook Page • Blue Leaves Scrapbook Page • Winter Scene Scrapbook Page

Beyond Traditional Scrapbooks

Memory Boxes 98

Photo Box • Familiar Faces • Mail Box

Preserving Old Photographs 106

Preserving Family Records 108

The Next Step • Beyond Names and Dates

Clip Art 111

Additional Information and Sources 127

Index 128

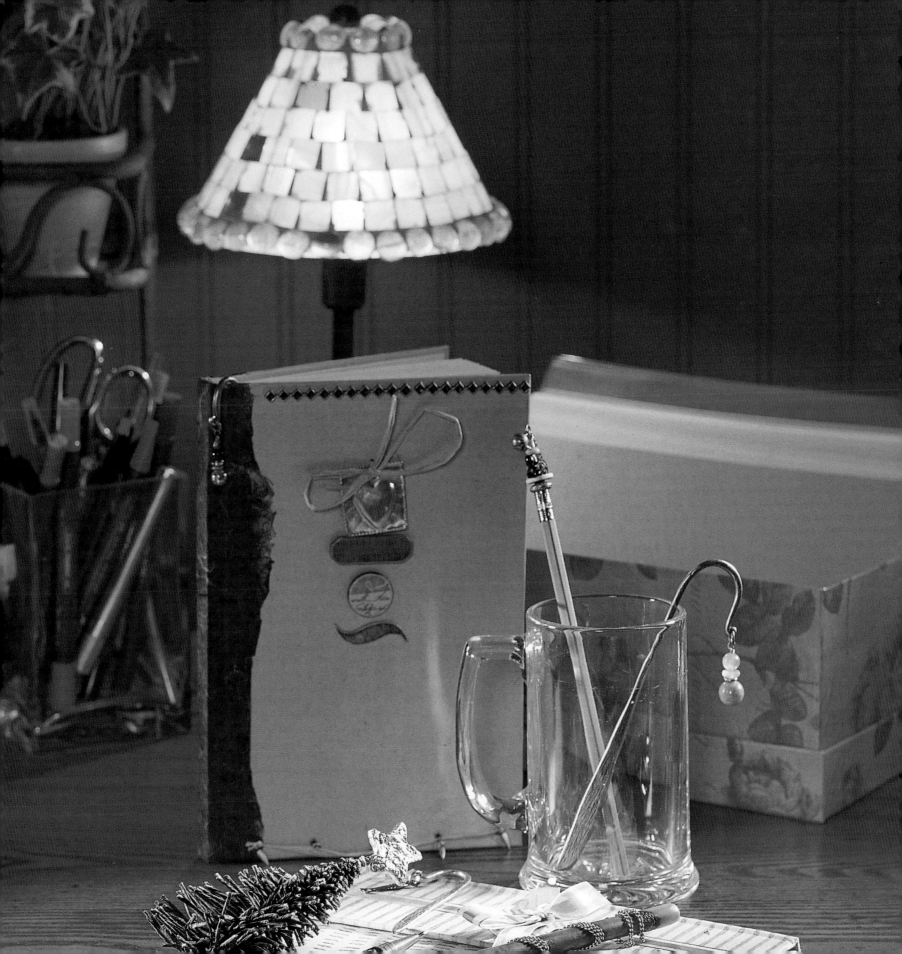

Introduction

If you don't recount your family history, it will be lost. Honor your own stories and tell them too. The tales may not seem very important, but they are what binds families and makes each of us who we are.
—Madeleine L'Engle

*P*oetry moves the soul, music stirs the spirit, beauty inspires the senses, and memories touch the heart. This touching of the heart is what makes memories so very precious to us, our families, and our friends. Remember the emotions experienced before the birth of a much-awaited child, your father's visions of his "little girl" on her wedding day, the sentiments expressed following the death of a loved one? Those rare moments should be collected for this generation and those to come. They should be recorded promptly and preserved indefinitely, so they will never be forgotten or inaccurately written by someone else.

Family faces, remembered events, and quoted sentiments recounted and described over the years by word of mouth are one way to hand down family histories. But like the game where a whispered sentence is passed from one child to the next, family stories can become blurred, distorted, or faded through the years. To accurately and timelessly preserve your most treasured moments, it's important to commit them to paper.

Between the protected pages of your family albums, memories become timeless tales told by ageless photographs of moments that someone wanted to remember. When preserved and combined with written words, bits of memorabilia, and pieces of art, they become your lasting, loving tribute.

Your family, like mine, has probably taken countless photographs over the years; but the pictures alone simply are not enough. When the photograph is taken you may be convinced that you'll always remember every detail of each special event, and for some of them you may. But what about the ones you don't remember perfectly? How will your children or your grandchildren or

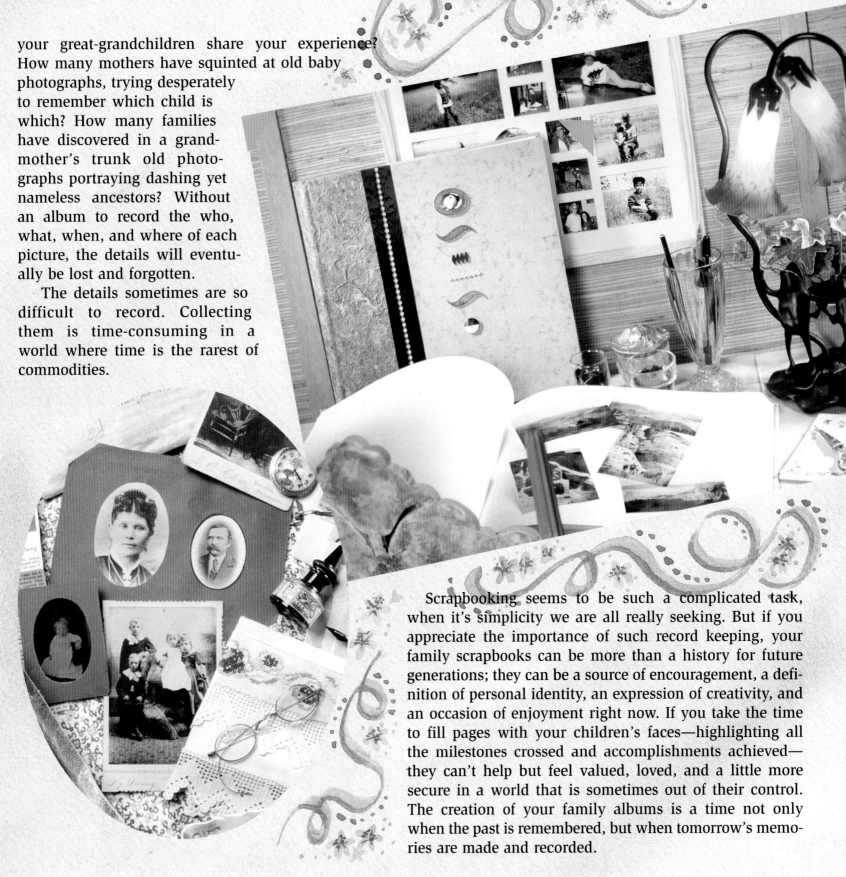

your great-grandchildren share your experience? How many mothers have squinted at old baby photographs, trying desperately to remember which child is which? How many families have discovered in a grand-mother's trunk old photo-graphs portraying dashing yet nameless ancestors? Without an album to record the who, what, when, and where of each picture, the details will eventu-ally be lost and forgotten.

The details sometimes are so difficult to record. Collecting them is time-consuming in a world where time is the rarest of commodities.

Scrapbooking seems to be such a complicated task, when it's simplicity we are all really seeking. But if you appreciate the importance of such record keeping, your family scrapbooks can be more than a history for future generations; they can be a source of encouragement, a defi-nition of personal identity, an expression of creativity, and an occasion of enjoyment right now. If you take the time to fill pages with your children's faces—highlighting all the milestones crossed and accomplishments achieved—they can't help but feel valued, loved, and a little more secure in a world that is sometimes out of their control. The creation of your family albums is a time not only when the past is remembered, but when tomorrow's memo-ries are made and recorded.

The time to record your memories is now. Begin with the pictures you took today, and don't be discouraged by the task of compiling the years and years of photographs that were taken before. Even if you have countless shoe boxes and drawers filled with old photos, it can be done. Simply set aside a little time on a regular basis. Turn it into a family event or an evening with friends, and eventually you will conquer even the highest mountain of beloved but previously ignored photographs and memorabilia.

Moments to Remember was written to help you with your resolution to record your memories. From the basics for preparing archival-quality scrapbooks to artistic concepts for creating scrapbook pages, it covers each and every aspect of scrapbooking.

I believe you'll find that scrapbooking is unlike any other art or craft. It's a beloved task that's never complete, but always treasured. Your scrapbooks are filled with your memories of yesterday, your emotions of today, and your dreams for tomorrow.

*Y*our scrapbook—filled with moments to remember, words to retell, keepsakes to treasure—must be made to last from your generation to the next. So many elements can damage your hard work and destroy these records of your memories.

Acid, dust, harsh sunlight, humidity, and unstable dyes are only a few concerns you may not be aware of that will cause endless problems. If you are careful and take simple precautions, you can avoid these problems and create a truly archival scrapbook. Sometimes these precautions make your scrapbooking slightly more expensive, but in a world where time is a high-priced commodity, every minute spent creating lasting keepsakes saves valuable time in the future—you won't have to redo all of your work because it didn't stand the test of time.

Acid is the biggest threat to scrapbooks. It's found in papers, glues, pens, stickers, and most of the other supplies that you may unwittingly use to create your scrapbook pages. Papers containing acids and ink from acidic pens will fade, tear, or bleed over time. High-acid glues or stickers will pass their acid content onto surrounding papers and photographs.

So please be aware of what you are buying. Scrapbook suppliers, craft stores, and stationery shops carry an ever-growing supply of acid-free products. Be careful to purchase only acid-free papers, adhesives, and stickers, as well as permanent-pigment pens. If you aren't sure and the label doesn't state "acid-free," don't buy the product. You can test the acid content of paper products by using one of the many pH-testing pens on the market. Simply make a small mark on the back of the paper. If the paper is acid-free, the mark will remain

blue; if there is any acid content, the mark will turn green; and if the acid content is high, the mark will change to yellow.

Perhaps there are keepsakes and memorabilia you want to include in your scrapbook regardless of their acid content, to make your memories complete. A perfect example is the artwork your child brought home on Mother's Day or the newspaper clipping when your son scored the winning goal in the championship game. To make these items truly acid-free you can do one of two things: You can make a photocopy of the piece on acid-free paper and place that in your scrapbook, while saving the original in a separate box you use for such valuable memorabilia; or you can purchase a special buffering spray (available in craft or art-supply stores) that neutralizes the acid in the paper and provides a protective coating to fight against acid recurrence.

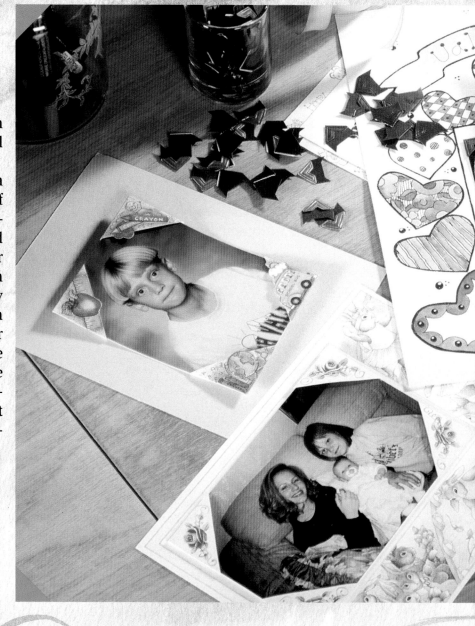

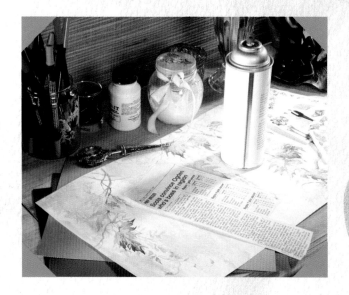

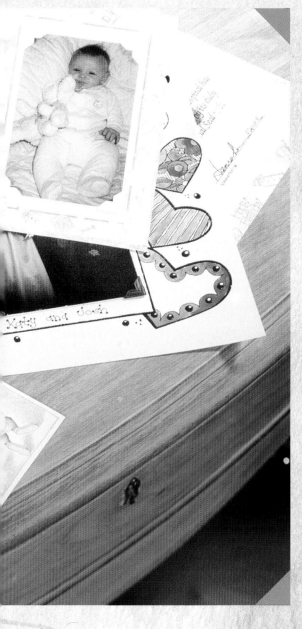

In addition to archival-quality supplies, don't forget to buy archival-quality scrapbook albums. Each album should have only acid-free covers, acid-free mounting pages, and sturdy construction. If you like clear plastic sheet protectors, make sure they are manufactured from a photo-safe plastic like Polypropylene, polyethylene, or mylar. Albums with self-stick pages must be replaced as soon as possible. They are covered with polyvinyl chloride (PVC), which causes photographs to become brittle, turn yellow, and fade. The adhesive in these self-stick albums will also destroy your photographs. It is absorbed into them, creating a bond that makes the photos difficult or impossible to remove. If you have as many of these albums as I do, take time now and remove your photographs to minimize any damage that's already been caused. Store the photos in a photo box until you're ready to add them to new scrapbook pages.

Remember: Truly archival scrapbooks are reversible—photographs placed in these albums can be removed again today, tomorrow, or a hundred years from now without any damage.

13

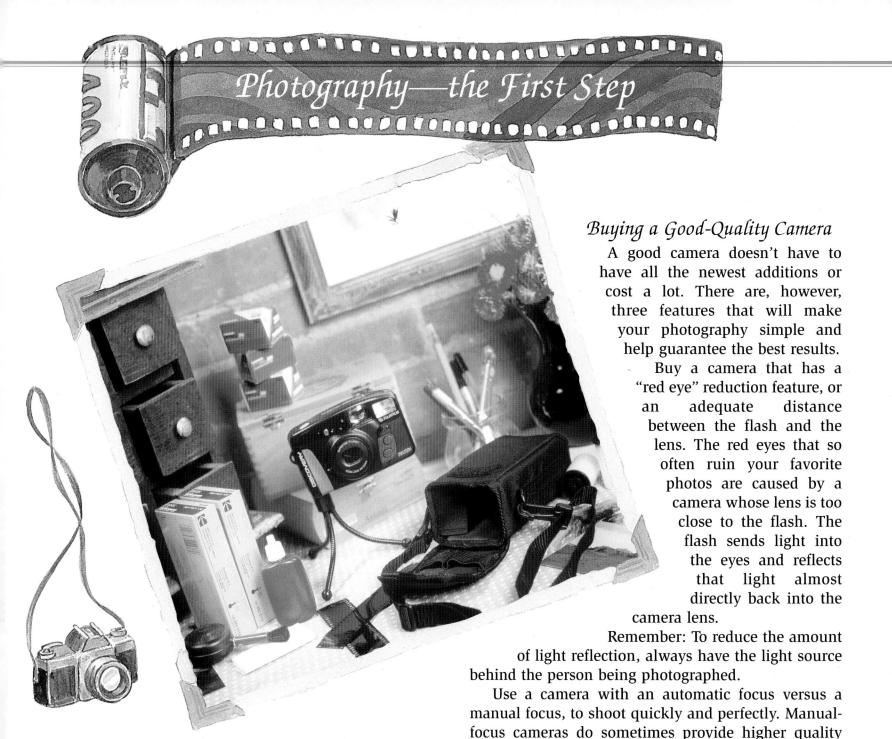

Buying a Good-Quality Camera

A good camera doesn't have to have all the newest additions or cost a lot. There are, however, three features that will make your photography simple and help guarantee the best results.

Buy a camera that has a "red eye" reduction feature, or an adequate distance between the flash and the lens. The red eyes that so often ruin your favorite photos are caused by a camera whose lens is too close to the flash. The flash sends light into the eyes and reflects that light almost directly back into the camera lens.

Remember: To reduce the amount of light reflection, always have the light source behind the person being photographed.

Use a camera with an automatic focus versus a manual focus, to shoot quickly and perfectly. Manual-focus cameras do sometimes provide higher quality photographs and allow more freedom in composition choices.

A camera with an optional dating feature will print the date right on the photograph—helping you later in organizing your photos—and also allows you to turn off the dating feature for more formal pictures.

*T*aking great pictures is your first step in making wonderful scrapbooks, and really good ones are not necessarily the result of a professional photographer, years of experience, or expensive equipment. All you need are a few basic photography "tips" and skills.

When you think
you are ready to snap the
picture, take a step or two closer
and then click the shutter. It
will make a difference!

Get in Close

When taking photographs, get close to your subject. Fill the frame so less cropping is necessary when you add the photos to your scrapbook.

Experiment with Angles

Take your photos from a variety of angles. Photographing your children at their level will mean more than when the picture is taken from your adult point of view. It seems more natural, and shows more of their expressions, their feelings, and who they are—really.

Remember: Shoot horizontal shots as well as vertical ones—it's often hard to remember to turn the camera, but it's easy to do and can be an improvement.

Shooting Outdoors

Outdoor photographs can be a big part of your family archive, and they are necessary to make your memories complete. For best results, the most basic rule is to avoid shooting when the person is squinting directly into the sunlight. Also make sure that the face is not in shadow.

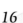

Catching Real Life

You will want "posed" photographs sometimes—whether you or a professional takes them—but you'll also want to catch those unplanned moments you never want to forget. Priceless photos retell stories of cake-smeared faces at a birthday party, smiles shared between friends, or family moments that are uneventful but memorable. These are the pictures that mean so much as the years pass.

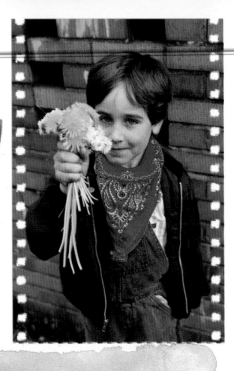

Manipulating Your Photos

As you create page designs for your scrapbook, you may want to try decorative backgrounds and unique layouts. With access to just a little computer technology (both skills and equipment), you can create endless "effects" in your photos. Even if you don't have a personal home computer with the needed color scanner, color printer, and photographic editing software, most full-service photo studios or quick print businesses have all that you need.

To create dramatic photographic effects, simply change your homey family photos into stylized art shots; manipulate standard cropping or edges into more unusual sizes, shapes, and borders; add dramatic colors or coloring effects such as posterization, watercolor, or hand tinting; remove the undesirable aspects of your picture (like the flower bouquet that was growing out of your father's head); or repair damaged photographs of loved ones from long ago.

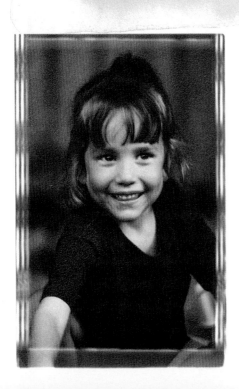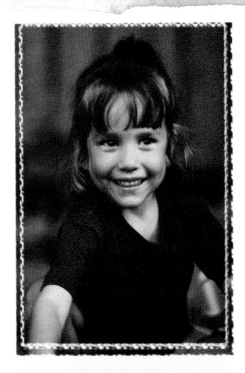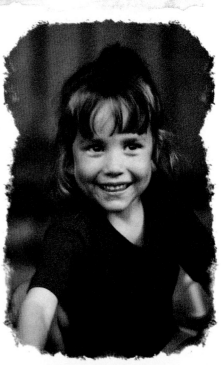

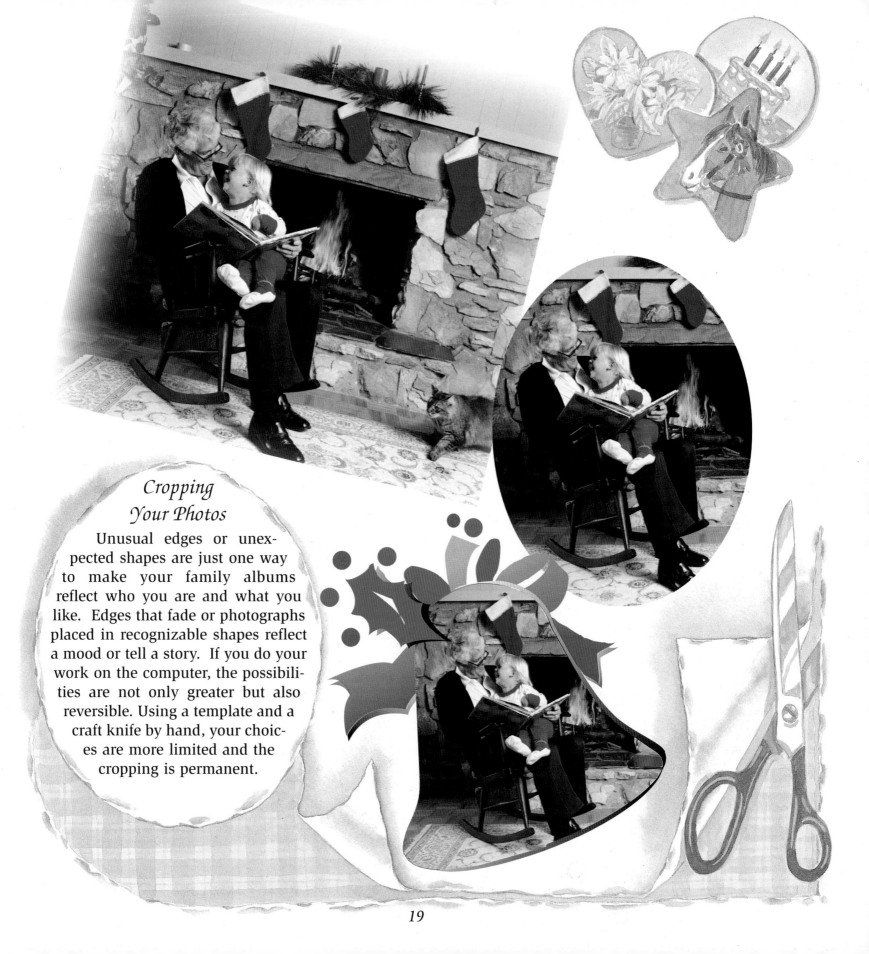

Cropping
Your Photos

Unusual edges or unexpected shapes are just one way to make your family albums reflect who you are and what you like. Edges that fade or photographs placed in recognizable shapes reflect a mood or tell a story. If you do your work on the computer, the possibilities are not only greater but also reversible. Using a template and a craft knife by hand, your choices are more limited and the cropping is permanent.

Original

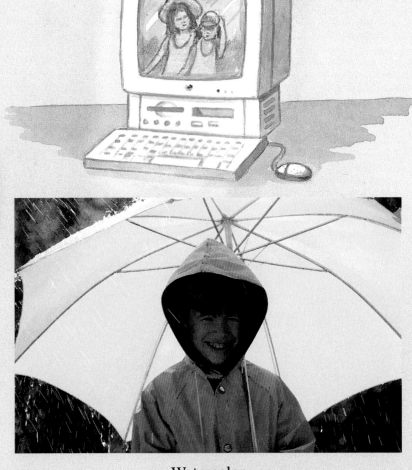

Photo Art

With a software program for photo editing, your standard photos can easily and inexpensively be transformed into beautiful and original works of art. Give your pictures the look of a watercolor painting; try oils, pastels, or acrylics; or tint your black and white photographs to make them look exactly like your grandmother's, which were painstakingly tinted by hand years ago.

Watercolor

Pastels

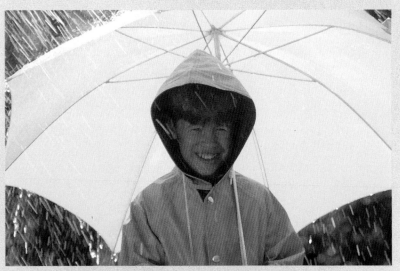

Acrylics

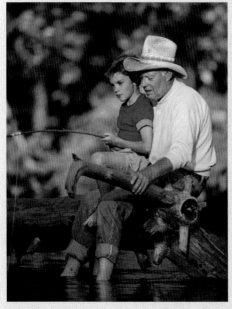

Original

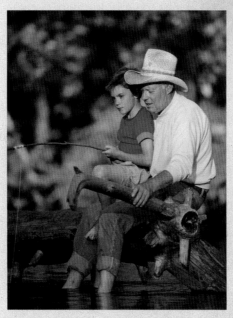

Black and white tinted

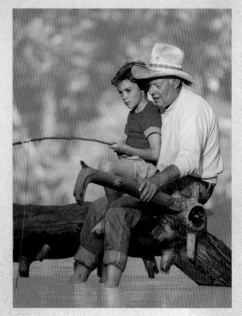

Duotone background

You can also work only on specific sections of a photograph. Try dry-brushing the background, leaving the people untouched; or turn the background into a duotone and leave the subjects in full color.

Original

Dry-brushed Background

Duotone

21

Zooming and Cropping

I know you have photographs that you love—except for that one little detail that's out of place or that you simply didn't notice when you took the picture. The camera bag sitting in the corner is too large and noticeable, the soles of your sister's shoes are caked with mud and grass—whatever the problem, it can be corrected with zooming in or creative cropping.

Remember: Your computer can zoom in on the parts of the photograph you like and eliminate all others—it's like having a second chance to take the perfect shot!

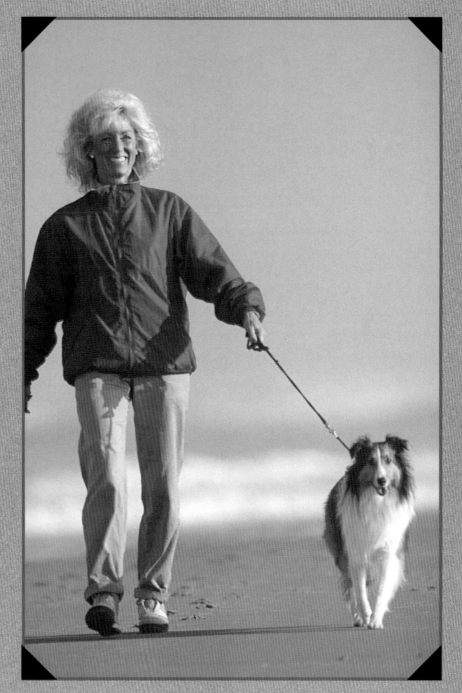

23

Hand Tinting

One of the most contemporary approaches to photography is the technique today's artists are using to imitate the hand-tinted photos of the past. It's a simple process, and you'll love doing it as much as you love the result.

To begin, you'll need a black and white photograph (or convert a color photo to black and white). Apply transparent color to specific sections or the entire image. Professional artists typically use photo-tinting oil paints, but these paints can be hard to find, difficult to use, and expensive. A number of new, simpler products are available for your use.

If you are uncertain about trying this technique on your actual photos, tint a black and white or sepia-toned copy of an original. Even vintage photographs can be copied and hand-tinted. When tinting an original photograph, make certain it has a matte finish. The color you apply is transparent, so you can paint directly over the images without covering them up. Since the details aren't lost, true artistic talent isn't necessary. When your tinting is complete, spray the photo with a matte acrylic sealer.

Artist-Quality Colored Pencils: This is the most highly recommended method for the non-professional. The photo on the opposite page was tinted using artist-quality colored pencils, which produce great results and are easy to use, even for the novice.

Colored pencils are available in a wide range of colors. When covering large areas, use soft circular motions to avoid scratching the surface. Blend with a cotton swab or a watercolor blending stump to smooth the colors. Colored pencils are wonderful tools when you are working on very small areas of a photo, such as the eyes or lips, and you can erase mistakes with an artist's eraser. They can also be used to touch up color photos with a matte finish.

There are a number of additional products available to hand tint your photos with. The end results and professional effects will vary from product to product. The final appearance will depend on your skill level as well as the materials used.

Chalk Pastels: Chalk pastels are inexpensive, come in a full vibrant spectrum of colors, and can be corrected with an artist's eraser. They are one of the easiest mediums for beginners, because an extra degree of control can be added to the pastels with an artist's liquid masking medium. The medium is applied with a paintbrush to the area outside where color is desired. After the medium dries, it shields the surrounding areas so color only goes where it's intended. When you finish coloring and blending, the masking medium rubs away with a finger. Chalk pastels are best for covering areas that don't have small details and they produce a chalk dust that needs to be gently blown off the surface.

Oil Pastels: Hand-coloring with oil pastels is very similar to coloring with chalk pastels. You can build the color by applying several layers. The liquid masking medium described above also works with oil pastels. Oil pastels are good for small details and colors can be blended using a watercolor blending stump. The color will adhere to photos, but it can't be used to hand-color photocopies.

Photographic Hand-Coloring Pens: Using coloring pens made specifically for hand-coloring photos is one of the most expensive methods. The dye in the pens penetrates the photographic emulsion, and the added color actually becomes part of the photo. Hand-coloring pens can be used on both matte and glossy photographs. They are simple to control, light in color, and easily removed when you make mistakes. You'll find that the color is less likely to fade over time than with other methods, and the surface of the photograph stays smoother after the artwork is complete. Photographs don't need to be sprayed before hand tinting with photographic pens.

Felt-Tip Markers: Artist-quality felt-tip permanent markers are used to color highlights on photographs. You must work quickly before the marker dries, in one small section at a time, blending in details with a cotton swab and a watercolor blending stump. Markers come in a wide variety of colors and are easy to use because of the different tip sizes that are available. The ones with finer tips are very useful when working in small areas. Markers produce the least professional results, but are relatively inexpensive and easy to use when coloring small areas.

\mathcal{D}o you have photographs everywhere? In your drawers and cupboards, tucked in old shoe boxes, stacked in attic chests, or piled high on desks and counters, still in their envelopes from the developer? When they're hidden away like this, you can't see them, nor can you hear them—which is sad, because the voices of the past and present are the music that fills our world and stirs our spirits. The photos we take whisper the voices of the ones we love, if only we can listen. But sometimes it seems as if we have forgotten how to listen.

So now is the moment to listen to the whispers, and your family photo album is the place to begin. It's true that organizing and preserving all these countless photos seems at first to be an impossible task. But it can be done, and it's your opportunity to hear the echoes of the ones you love. As you begin to organize and sort through the stacks of photos, you'll see the faces of loved ones and places remembered, hear your three-year-old squeal on Christmas morning, feel your spirits rise at the sound of laughter from friends, or visualize yourself escaping to a place where wind rustles through the trees. Your family photo album will hold the sounds of your memories, the

memories of your heart, and the times and places where others have been and you can only imagine. Isn't it easy to see that you must begin now?

When you start organizing, the best place to begin is the present. Don't try to tackle twenty- or thirty-year-old photographs—start with the ones that were taken yesterday or last week. Organize the photos in an album or photo box, put names and dates on each picture, and record the memories that come to mind and fill your heart. Starting with the present will keep you from feeling as if you're always behind. As time allows, you'll work on the older material and, eventually, all your pictures will be in scrapbooks where they'll whisper to you each time the books are opened and enjoyed.

Organizing a Work Space

It's important to set up a workplace of your own. Try to find a space where projects can sit undisturbed for a while until you return. This will make it easier to sit down for an hour or a moment to jot down a memory you'd forgotten. If the kitchen table is the only work space you have, store your supplies and photos in specially labeled boxes that can be accessed quickly when you do have time to work.

Organizing Photographs

Wash your hands before you begin. Clean hands are a necessity when working with photos. Even seemingly clean fingers produce oils that leave prints on photos, and the prints grow more noticeable as the pictures age. You can prevent such damage by limiting the amount of handling, touching photos only from the side, or using special cotton finishing gloves.

First, you should organize your photographs by year, by family member, by occasion, or by any other system you prefer. Use file folders or large mailing envelopes marked for each category to help in the sorting process.

As pictures are sorted, record important information on the back of each one, using a blue photo-safe pencil to write names, dates, and memories. Don't write on the photo with a ballpoint pen, felt-tip marker, or regular pencil—these will eventually damage the picture.

The next step is to divide the photos by scrapbook page. Choose three to five photographs per page—grouping them by theme, event, or person—and then put them in a separate envelope or folder. When you are ready to work on your scrapbook, the photographs for each page will be easily accessible.

Once you organize your collection, keeping up will be so much easier and more fun. Have rolls of film developed immediately, write the necessary information on the back of each photo as it comes back from the developer, then place it in the correct file. You'll find that after you've worked out the organizational system, the most difficult part of creating your scrapbooks is over.

Organizing Negatives

Don't forget the negatives—they are just as important as the photos themselves. Duplicates of pictures can be made for years to come if the negatives are organized and in good condition. They should never be stored loose in photo processing envelopes because they rub against each other, destroying the quality of the images. Store negatives safely in negative sleeves and keep them in a three-ring binder or indexed photo box. Organize them the same way you do the photographs, but don't cut them apart. Keep the strips intact as they come from the developer.

Storing Negatives and Photographs

Proper storage of negatives and photographs is absolutely necessary. You may now be keeping your memories in the worst possible places—hot, dusty, or damp attics; cold, musty, leaky basements. It's best to store them in the same area of your home where your family spends most of its time, because any room that's climate controlled is an ideal place for storage. It's also wise to store negatives and photographs in separate places so that your photos can be preserved in the event of fire or natural disaster.

Designing Scrapbooks—the Third Step

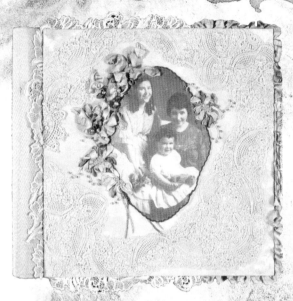

\mathcal{N} ow that you've worked very hard and all of your photographs are organized, you can create the binders and the pages that will hold the memories of your life and the lives of others. You can tell the stories and touch the places of those you love, those you have forgotten, and those you never knew.

Scrapbook Covers

Start by choosing a scrapbook you love. Select wisely and carefully, because it will house precious things you hold most dear for a very long time. Some books are bound and filled with paper mounting pages, others are three-ring binders with plastic page protectors. If you choose a bound scrapbook, you can work directly on the scrapbook page or on a cardstock mounting page attached to the album page. If you choose a scrapbook binder filled with page protectors, your

designs will be completed on cardstock mounting pages placed back to back in the protectors.

The cover of your scrapbook should tell as much of your story as the inside pages. You can buy one, make one, or just add to one that's almost perfect. Before you're finished, you'll own a library of scrapbooks. So think about whether you want some or all to match, or if you want each to be different. Maybe you want a series of lookalike scrapbooks that tell a continuing story, while others with stories of their own have a very different style.

Scrapbook Pages

The creative process of designing and completing your pages requires certain basic supplies including scissors, a ruler, a blue photo-safe pencil, a set of permanent, acid-free pens or markers, acid-free adhesive or self-stick photo corners, and for binder albums, card-stock paper for mounting. You'll want to add materials that will help retell your story—colored or textured papers, stencil or plastic cutouts, stickers, paints, bits of memorabilia, prayers, quotes or famous sayings, scissors with unique cutting edges, or anything else that stirs your imagination.

Never use adhesives like craft glue, rubber cement, or transparent tape, which yellows over time, loses its adhesion, and leaves a residue on whatever it touches. Avoid paints that smear after they are dry, or pieces of memorabilia that aren't flat and will press into several other pages, marking much-loved photos.

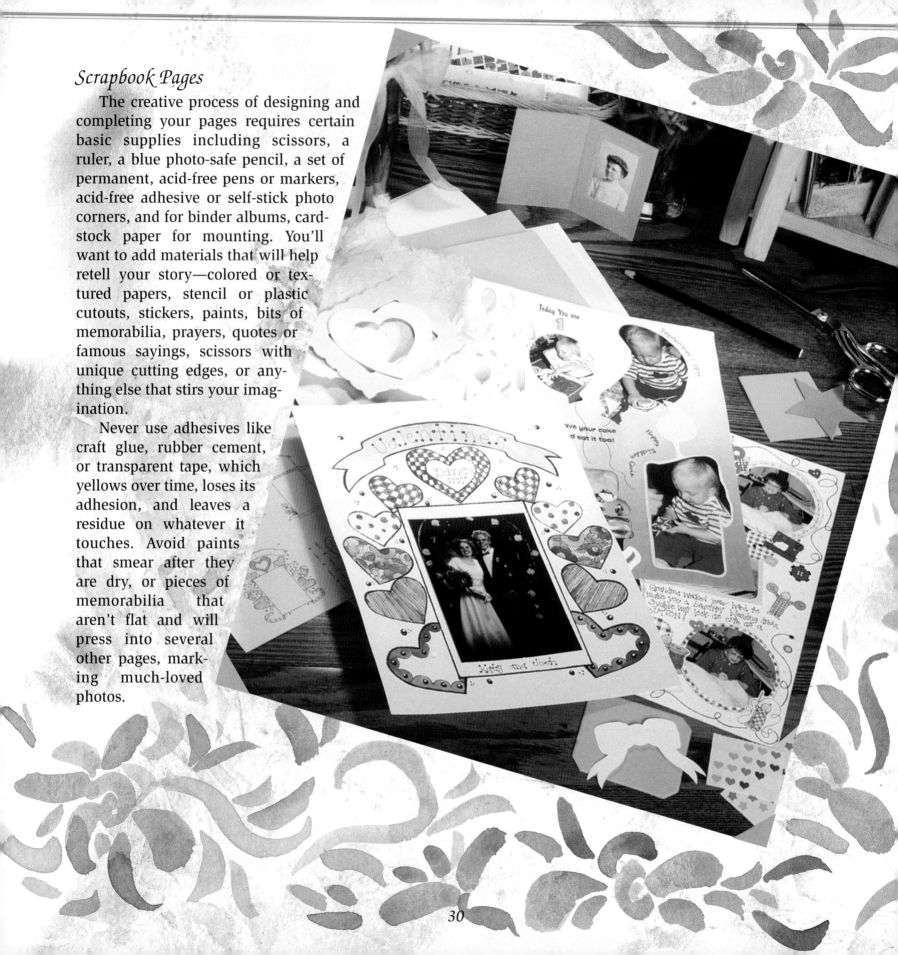

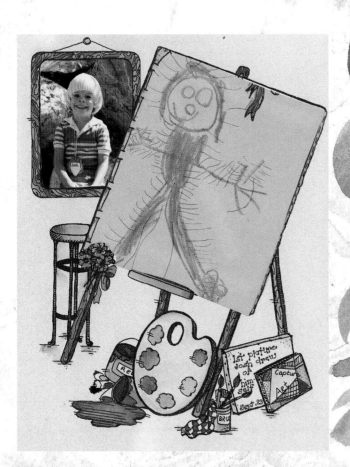

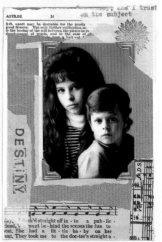

To begin your page, select an envelope in which you have stored three to five pictures. These can simply be attached to a plain page with photo corners, or you can design a page that tells more of a story through its artwork. The pages can be very sweet and simple, or more complex and somewhat overcrowded. There is no right or wrong in a page design—just remember that the photos should be the central focal point, and the page design should accent, not obscure them.

Once you've completed a page design and attached the photos, you can write all of the important information about each one on the page too. Include the names of people in the picture, the date and place where it was taken, and any other information you want to remember.

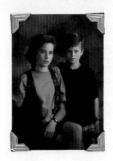

The face of all the world changed when first I heard the footsteps of your souls.

Those Who Hear Not The Music Think The Dancers Mad.

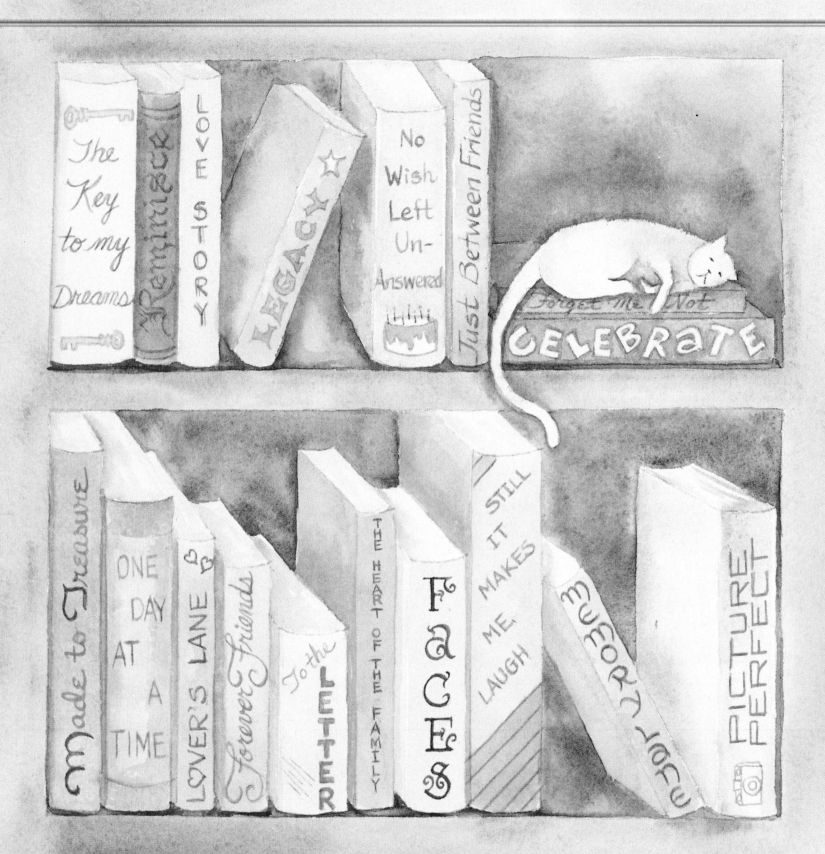

Scrapbook Covers

*T*he cover of your scrapbook creates a first impression of what awaits within. Give some thought to what will make your cover wonderful, inviting those who pick it up to open it and discover what it holds within.

Start your cover design with a beautiful title—perhaps this page holds one that's just right for what you want to say.

A
Charmed Life

Winds of Change

Wrapping up
Memories

2 good
+2 be
4 gotten

Back to Basics

Now and Forever

That's Life!

That's All Folks!

S
t
e
p
 by
 S
 t
 e
 p

Family Ties

One to Grow On

OUR FAMILY'S
CHECKERED PAST

Lasting
Moments

Bare Necessities

Moments of Truth

When All Is Said and Done

A Dream Come True

Once in a Lifetime

loving every Minute

Life in the Fast Lane

On a Wing & a Prayer

Only Time Will Tell

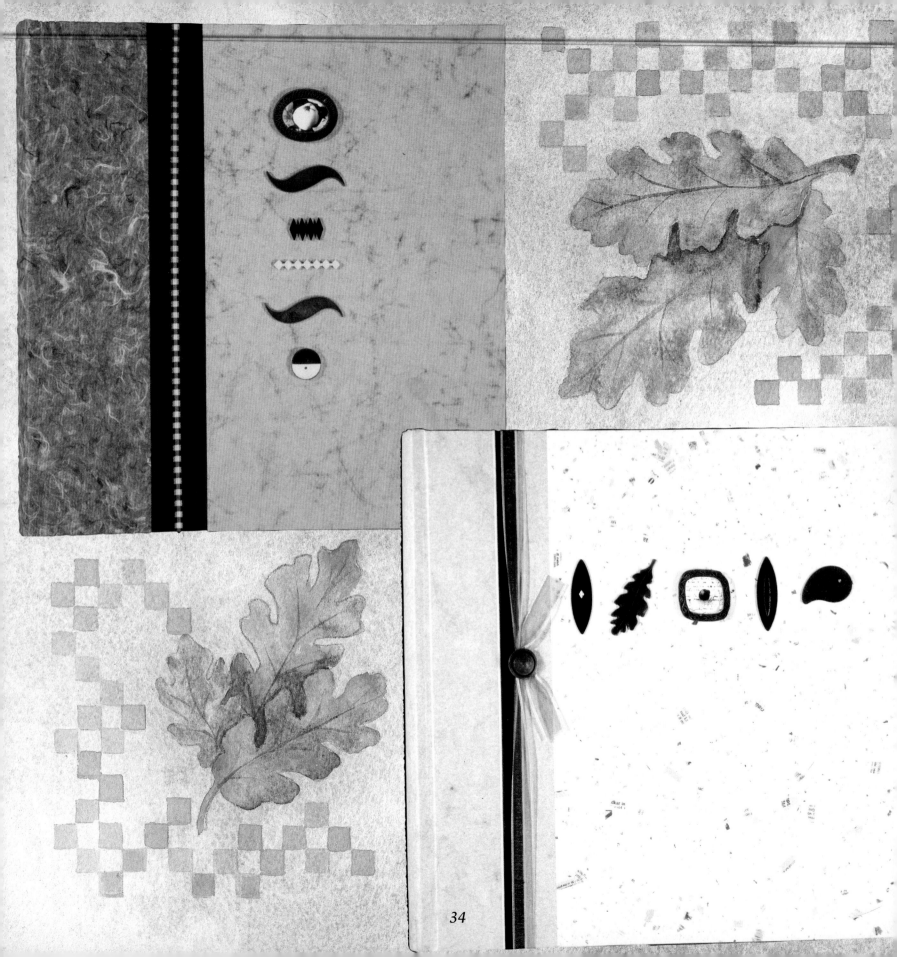

The scrapbook market is in full bloom, and new products and tools are only a small part of the growth. The supply and variety of keepsake scrapbooks have grown. Albums are available in countless styles and a large assortment of unique shapes and sizes. You can use a cover as is, or personalize it with family names or photographs.

Ribbons, tassels, handmade papers, and vintage charms make these fine Elements Albums from The Cornelia Collection extraordinary. Each signed and numbered scrapbook features a unique arrangement of striking details that makes it more a work of art than a book. The albums are handmade, and all materials are of archival quality.

You can explore new album resources by checking out advertisements in craft magazines, displays at craft galleries, and collections in fine-book catalogues. Check the resource list at the end of this book for suggestions.

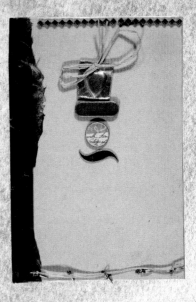

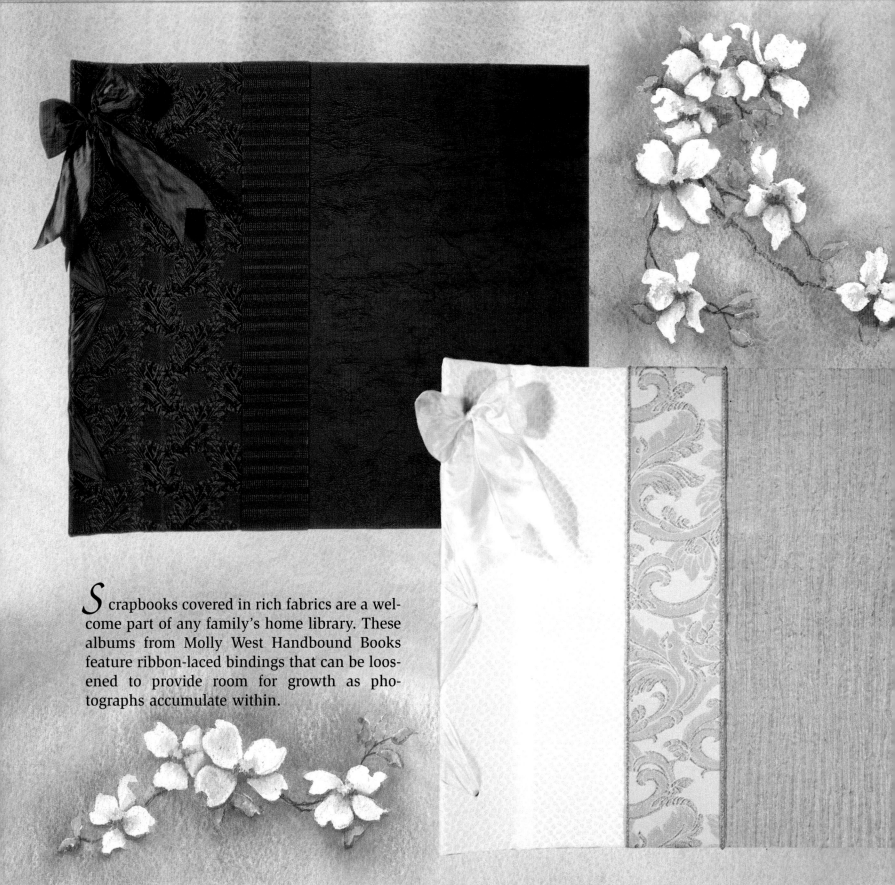

S crapbooks covered in rich fabrics are a welcome part of any family's home library. These albums from Molly West Handbound Books feature ribbon-laced bindings that can be loosened to provide room for growth as photographs accumulate within.

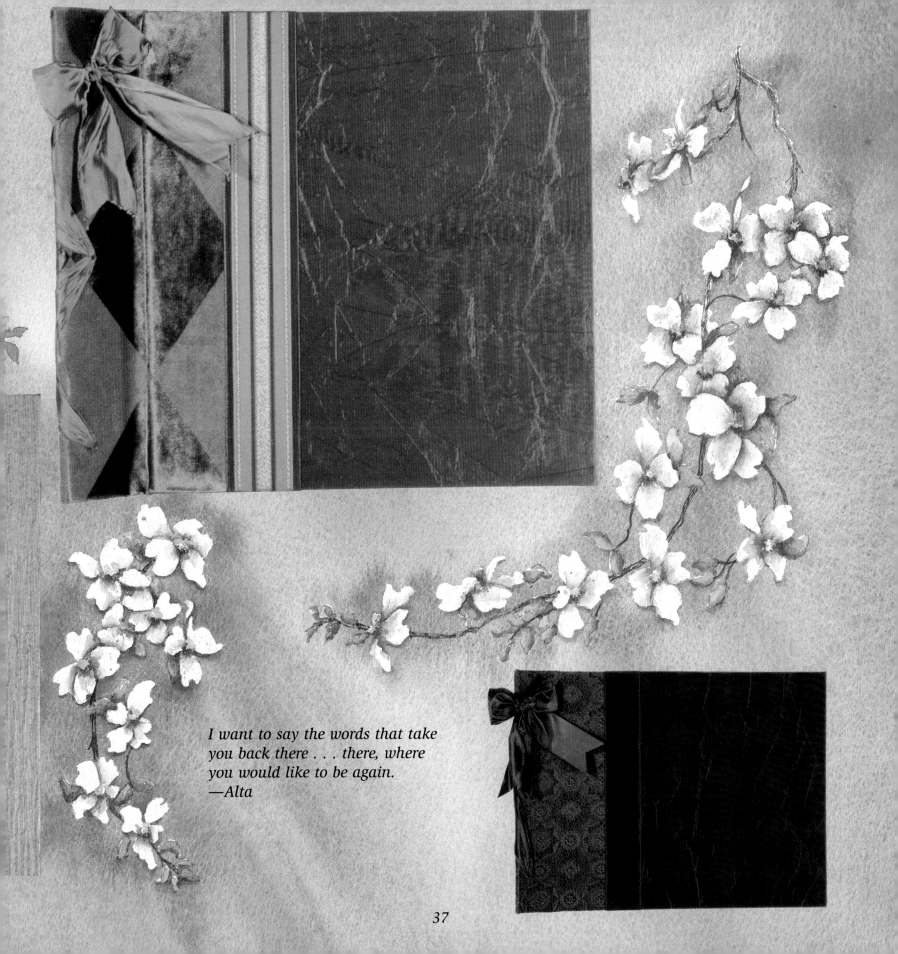

I want to say the words that take
you back there . . . there, where
you would like to be again.
—Alta

Little girls are precious gifts, wrapped in love serene. Their dresses tied with sashes, and futures tied with dreams...

—Nay Talbot-Bowsay

Keeping a diary remains, in any busy life, a piece of hard evidence that every now and then you take a moment to discuss things only with yourself.
—Perri Klass

𝒫aper-covered scrapbooks provide a blank canvas for you to explore your own creativity and self-expression. These charming albums designed by Books Nouveau are beautiful without added personalization. But you can make yours unique, by placing photographs in fascinating geometric shapes, painting a series of sweet designs, or adding gilded lettering or shaped wired highlights. Each addition you attach will magnify the scrapbook's artistic impact and make the book a personal reflection of you and your loved ones.

Purchased albums are a good way to simplify the process of designing your scrapbook. If you buy the basic book as a foundation, you won't have to start from scratch, and you can concentrate on the more enjoyable parts of the design. Leave the measuring, heavy cutting, and binding to the manufacturer!

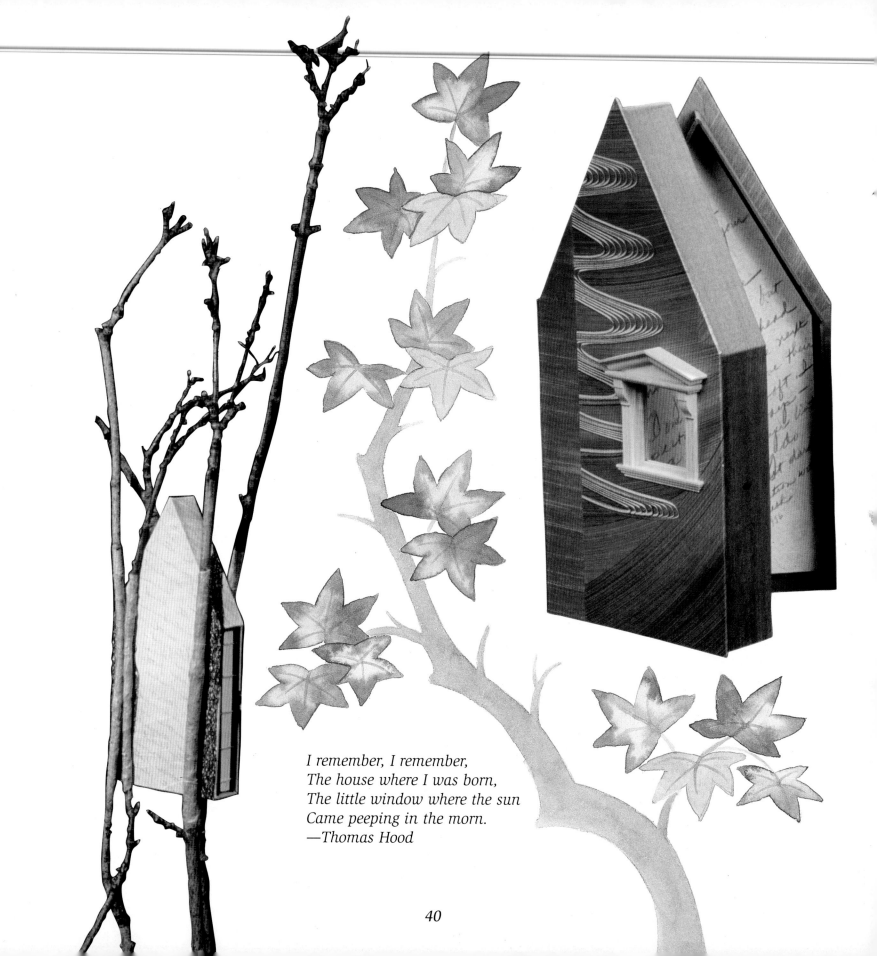

I remember, I remember,
The house where I was born,
The little window where the sun
Came peeping in the morn.
—Thomas Hood

40

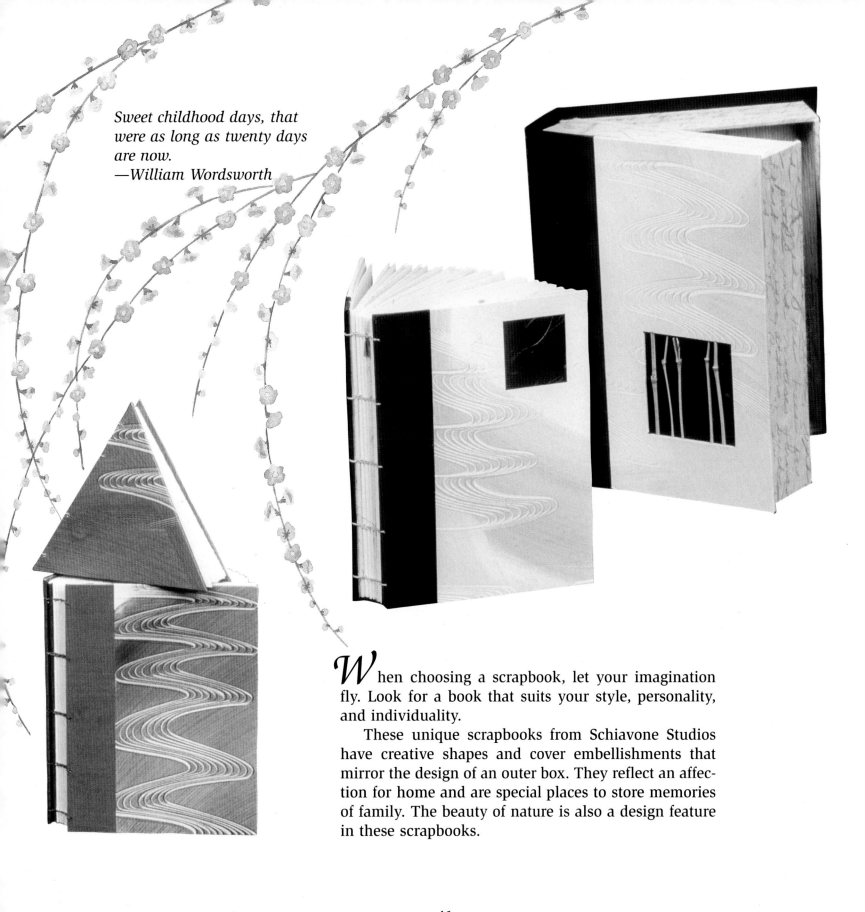

Sweet childhood days, that were as long as twenty days are now.
—William Wordsworth

\mathcal{W}hen choosing a scrapbook, let your imagination fly. Look for a book that suits your style, personality, and individuality.

These unique scrapbooks from Schiavone Studios have creative shapes and cover embellishments that mirror the design of an outer box. They reflect an affection for home and are special places to store memories of family. The beauty of nature is also a design feature in these scrapbooks.

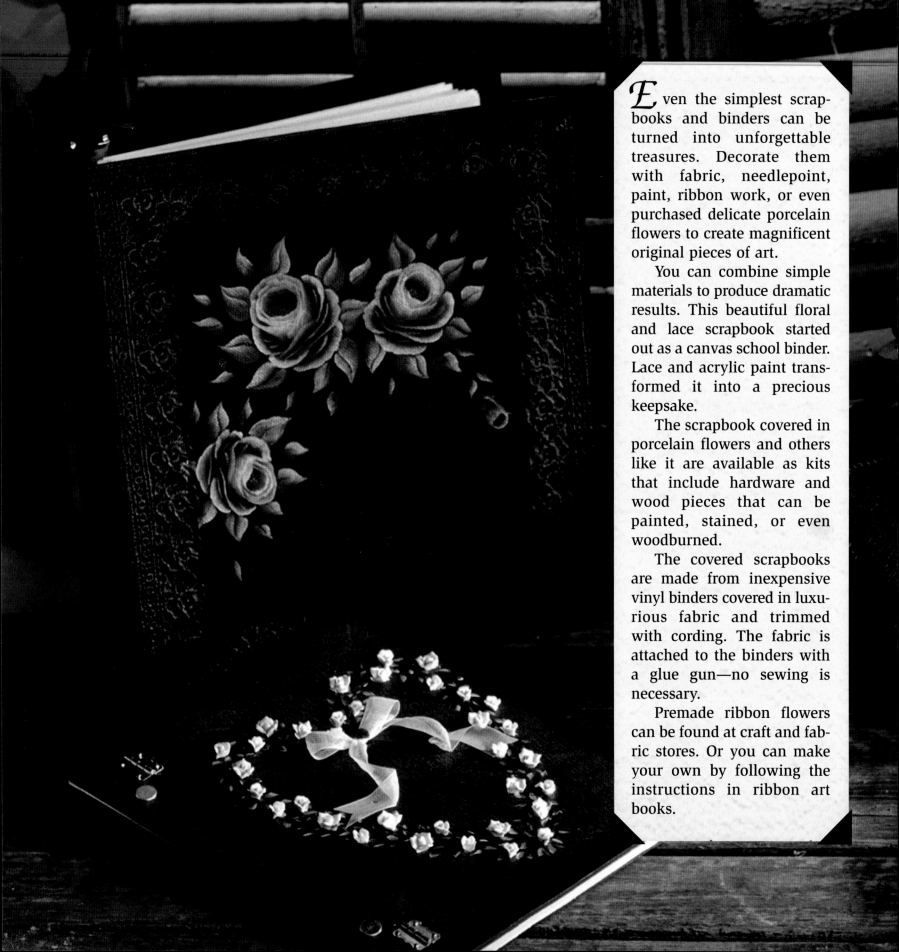

Even the simplest scrapbooks and binders can be turned into unforgettable treasures. Decorate them with fabric, needlepoint, paint, ribbon work, or even purchased delicate porcelain flowers to create magnificent original pieces of art.

You can combine simple materials to produce dramatic results. This beautiful floral and lace scrapbook started out as a canvas school binder. Lace and acrylic paint transformed it into a precious keepsake.

The scrapbook covered in porcelain flowers and others like it are available as kits that include hardware and wood pieces that can be painted, stained, or even woodburned.

The covered scrapbooks are made from inexpensive vinyl binders covered in luxurious fabric and trimmed with cording. The fabric is attached to the binders with a glue gun—no sewing is necessary.

Premade ribbon flowers can be found at craft and fabric stores. Or you can make your own by following the instructions in ribbon art books.

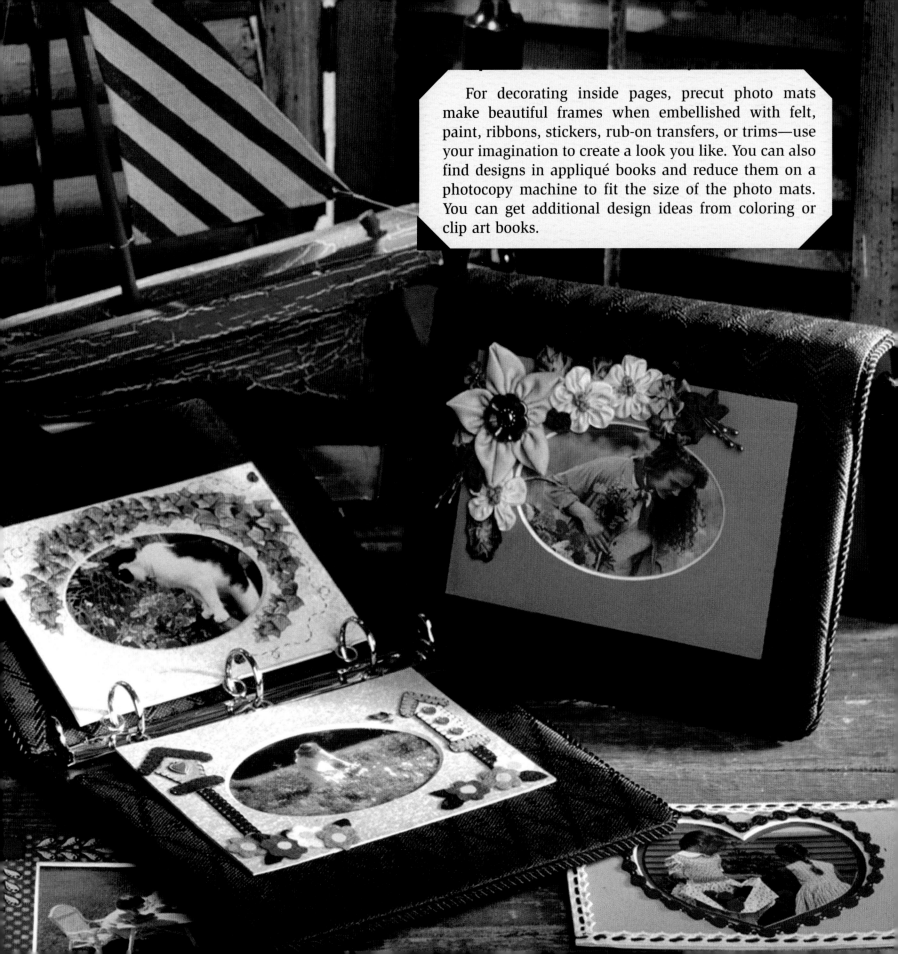

For decorating inside pages, precut photo mats make beautiful frames when embellished with felt, paint, ribbons, stickers, rub-on transfers, or trims—use your imagination to create a look you like. You can also find designs in appliqué books and reduce them on a photocopy machine to fit the size of the photo mats. You can get additional design ideas from coloring or clip art books.

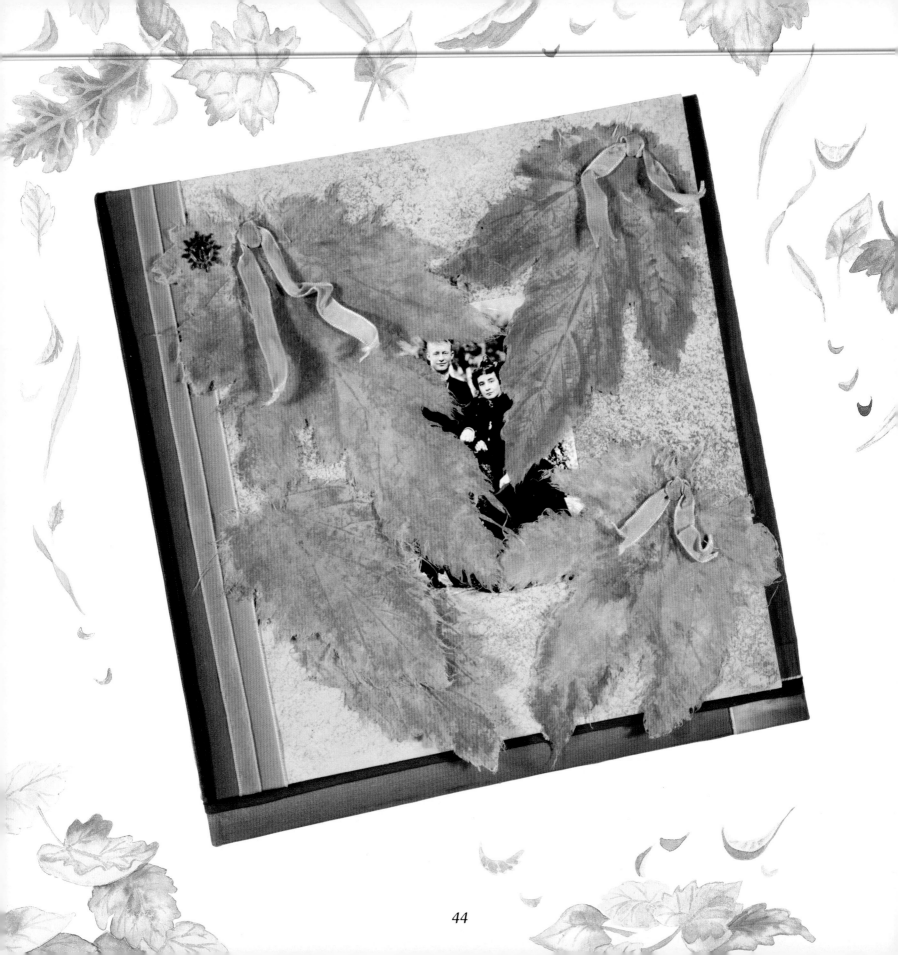

The breathtaking beauty of nature provides inspiration for a garden full of scrapbook surprises. Leaf rubbings or prints combined with the weathered vintage maps and antique photographs speak of autumn,

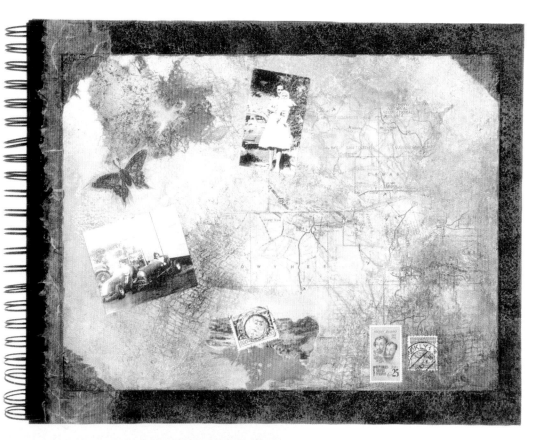

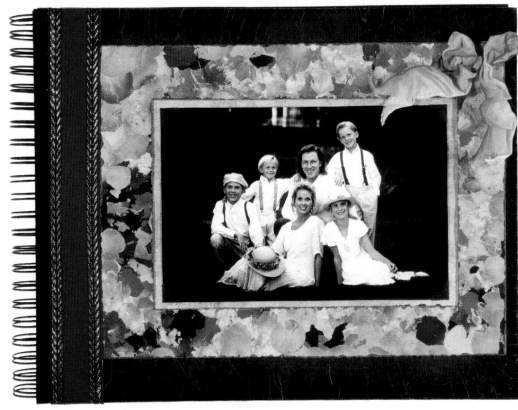

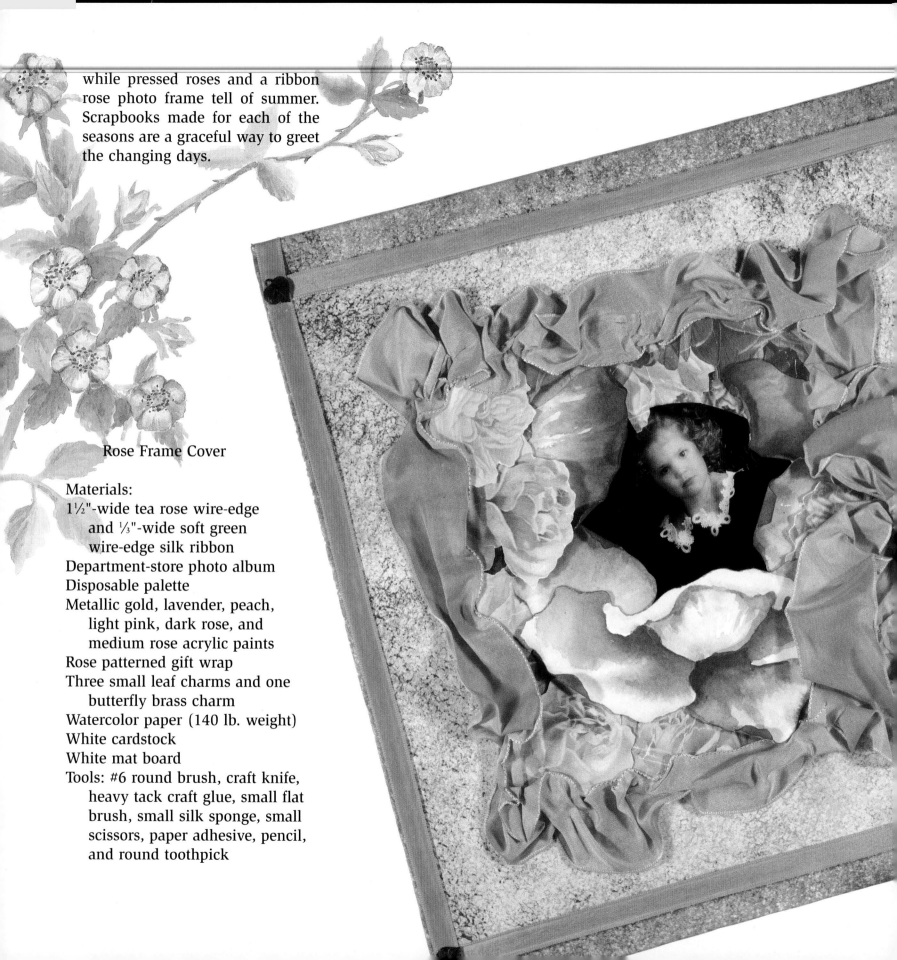

while pressed roses and a ribbon rose photo frame tell of summer. Scrapbooks made for each of the seasons are a graceful way to greet the changing days.

Rose Frame Cover

Materials:
1½"-wide tea rose wire-edge and ⅓"-wide soft green wire-edge silk ribbon
Department-store photo album
Disposable palette
Metallic gold, lavender, peach, light pink, dark rose, and medium rose acrylic paints
Rose patterned gift wrap
Three small leaf charms and one butterfly brass charm
Watercolor paper (140 lb. weight)
White cardstock
White mat board
Tools: #6 round brush, craft knife, heavy tack craft glue, small flat brush, small silk sponge, small scissors, paper adhesive, pencil, and round toothpick

How To:

Trim mat board ½" smaller than front of album. Using a sponge and acrylic paints, sponge desired texture onto album front and back, and onto album mat board. Let dry. Cut gift wrap 2" smaller than mat board. Using flat brush, brush a thin layer of paper adhesive onto front of mat. Center gift wrap on front of mat and gently smooth. Cut rose motifs from remaining gift wrap. Brush paper adhesive onto cardstock and adhere rose motifs. Let dry, then cut out motifs. Using large rose petals on this page for pattern, draw rose petals on watercolor paper. Shaded areas on pattern indicate where petals will be curled. Cut petals from paper. Dilute acrylic paints with water 1:2 on disposable palette. With the round brush, apply water to each petal shape so that it glistens. Dry brush, then pick up light pink on brush tip and apply to wet surface. The paint will feather and bleed at the edges. Let dry. Repeat process using medium rose and dark rose paints, applying clean water to areas where these colors will be applied and carrying the dark rose paint over the edges to the back side of the petals. Curl edges of petals by wrapping around a toothpick. Arrange and adhere roses and rose petals around photo. Using paper adhesive, adhere green ribbon to outside edge of mat board. Tuck raw edges over corner edges and glue to secure. Adhere charms at corners with craft glue.

Adhere mat board to front of album. Crinkle tea rose ribbon and glue around outside edge of roses. Tie bow and trim tails as desired.

Faraway Places Cover

Materials:
3-ring binder
Assorted decorative papers
Découpage medium
Gold foil
One yard ribbon
Postcard
Two 1" tassels
Tools: ¾" flat brush and sponge brush

How To:
Use a sponge brush to apply a coat of découpage medium to outside of album cover. Let dry. Tear decorative papers and foil into assorted shapes and sizes, and gently tear edges of postcard. Arrange papers on cover and adhere in place using the découpage medium. Use a flat brush and more découpage medium to smooth papers. Adhere postcard, ribbon, and tassels to front cover. Apply three coats of découpage medium to completed cover, allowing each coat to dry thoroughly before applying next coat.

D ecorative papers applied to plain binders produce extraordinary scrapbook covers. You can use handmade Japanese papers, museum-reproduction wrapping papers, wallpapers, and cards in an endless array of colors, textures, and patterns to cover scrapbook binders. Use complementary ribbons, lace, cording, and even tassels to finish the look.

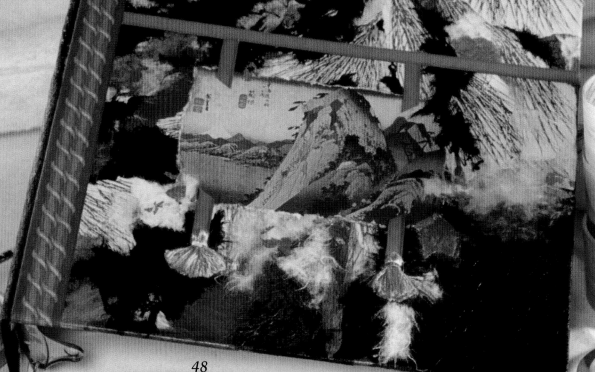

Japanese Ribbon Cover

Materials:
Decorative paper in five different patterns
Découpage medium
Department-store photo album
One yard each of seven different ribbon
 patterns in assorted widths
Tools: ¾" flat brush, pencil, ruler, scissors,
 sponge brush, and waxed paper

How To:
Use a sponge brush to apply a coat of découpage medium to inside and outside of album cover. Let dry. Measure and cut decorative papers into 1" to 2"-wide strips. Leave an extra 1" on top and bottom edges and on left and right sides to wrap to inside of cover. Arrange paper strips on cover and adhere in place using the découpage medium. Leave ends of paper free. Use a flat brush and more découpage medium to smooth paper strips. When all strips are adhered to front and back, wrap and adhere free ends to inside of cover. Adhere ribbons over paper seams, wrapping ends to inside of cover as before. Dilute découpage medium with water 3:1. Mix well, then brush three coats onto cover, making certain entire surface is generously covered. Allow each coat to dry thoroughly before applying next coat. When final coat is dry to the touch, place cover between sheets of waxed paper and weight down with a heavy object for two to three days to flatten.

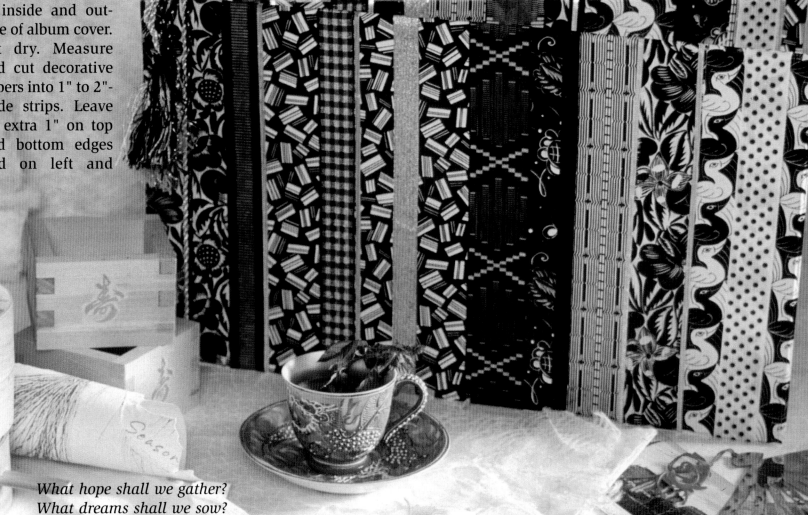

What hope shall we gather?
What dreams shall we sow?
Where the wind calls our wandering footsteps, We go.
 —Sarojini Naidu

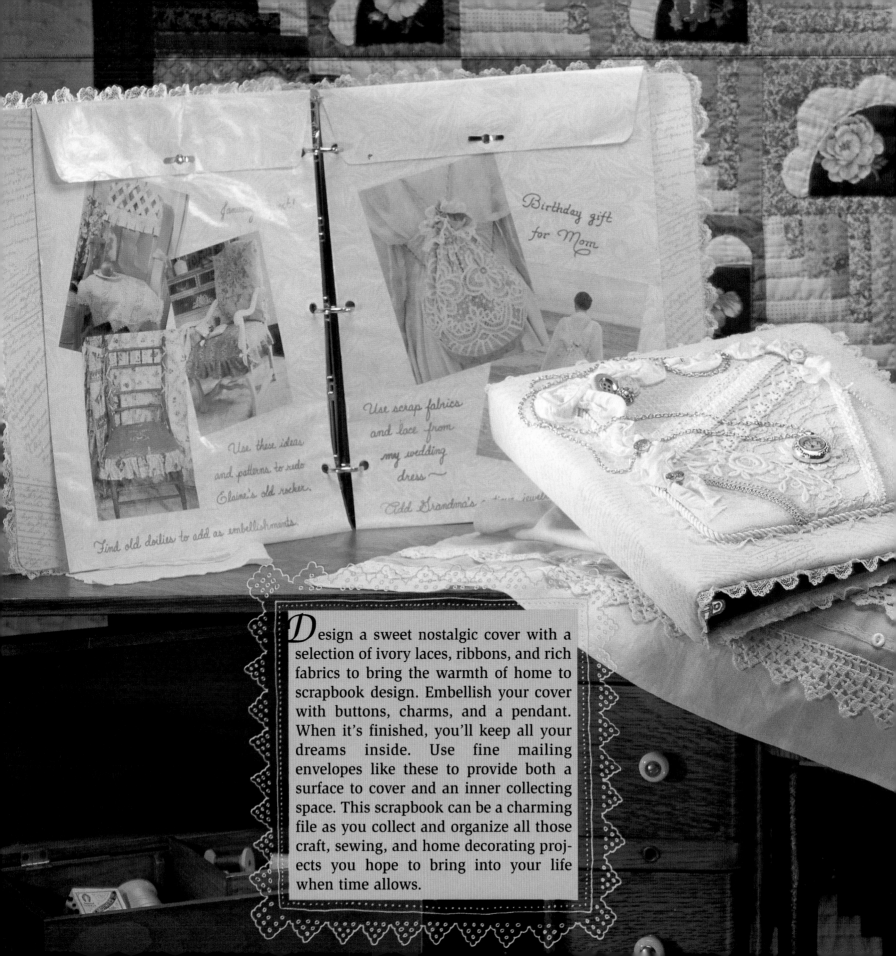

January ... 1

Birthday gift for Mom

Use these ideas and patterns to redo Elaine's old rocker.

Use scrap fabrics and lace from my wedding dress ~

Add Grandma's ... jewel...

Find old doilies to add as embellishments.

Design a sweet nostalgic cover with a selection of ivory laces, ribbons, and rich fabrics to bring the warmth of home to scrapbook design. Embellish your cover with buttons, charms, and a pendant. When it's finished, you'll keep all your dreams inside. Use fine mailing envelopes like these to provide both a surface to cover and an inner collecting space. This scrapbook can be a charming file as you collect and organize all those craft, sewing, and home decorating projects you hope to bring into your life when time allows.

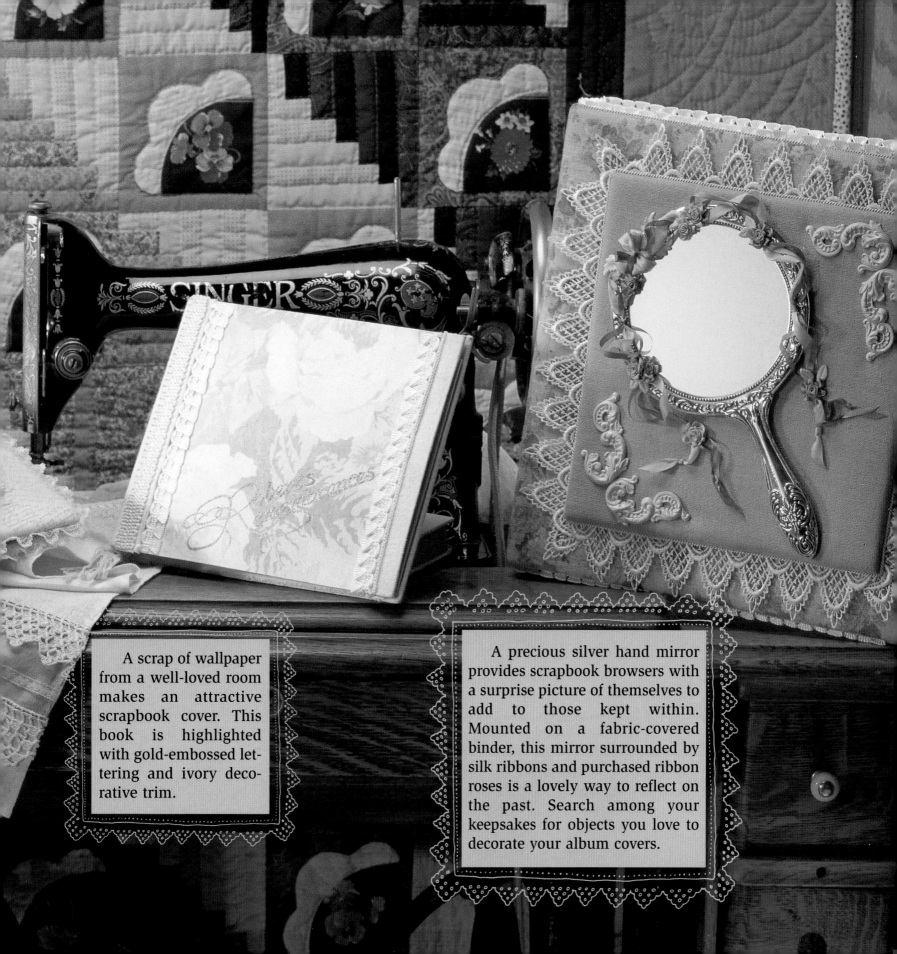

A scrap of wallpaper from a well-loved room makes an attractive scrapbook cover. This book is highlighted with gold-embossed lettering and ivory decorative trim.

A precious silver hand mirror provides scrapbook browsers with a surprise picture of themselves to add to those kept within. Mounted on a fabric-covered binder, this mirror surrounded by silk ribbons and purchased ribbon roses is a lovely way to reflect on the past. Search among your keepsakes for objects you love to decorate your album covers.

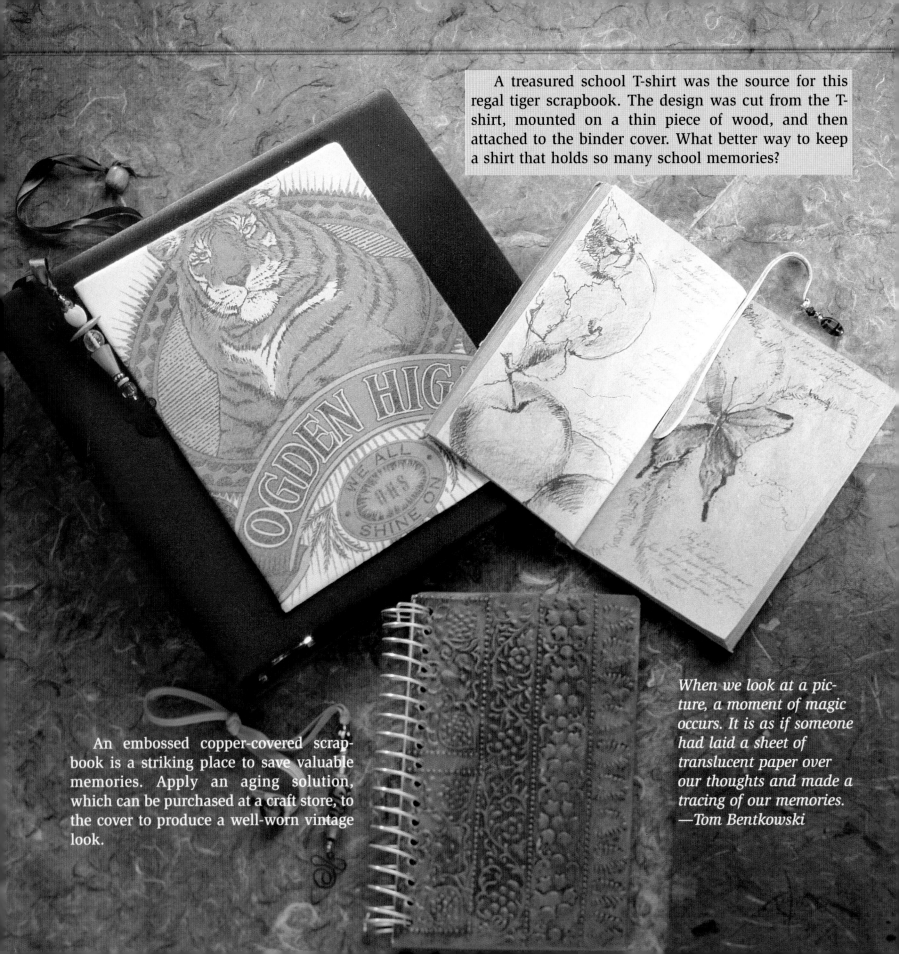

A treasured school T-shirt was the source for this regal tiger scrapbook. The design was cut from the T-shirt, mounted on a thin piece of wood, and then attached to the binder cover. What better way to keep a shirt that holds so many school memories?

An embossed copper-covered scrapbook is a striking place to save valuable memories. Apply an aging solution, which can be purchased at a craft store, to the cover to produce a well-worn vintage look.

When we look at a picture, a moment of magic occurs. It is as if someone had laid a sheet of translucent paper over our thoughts and made a tracing of our memories.
—Tom Bentkowski

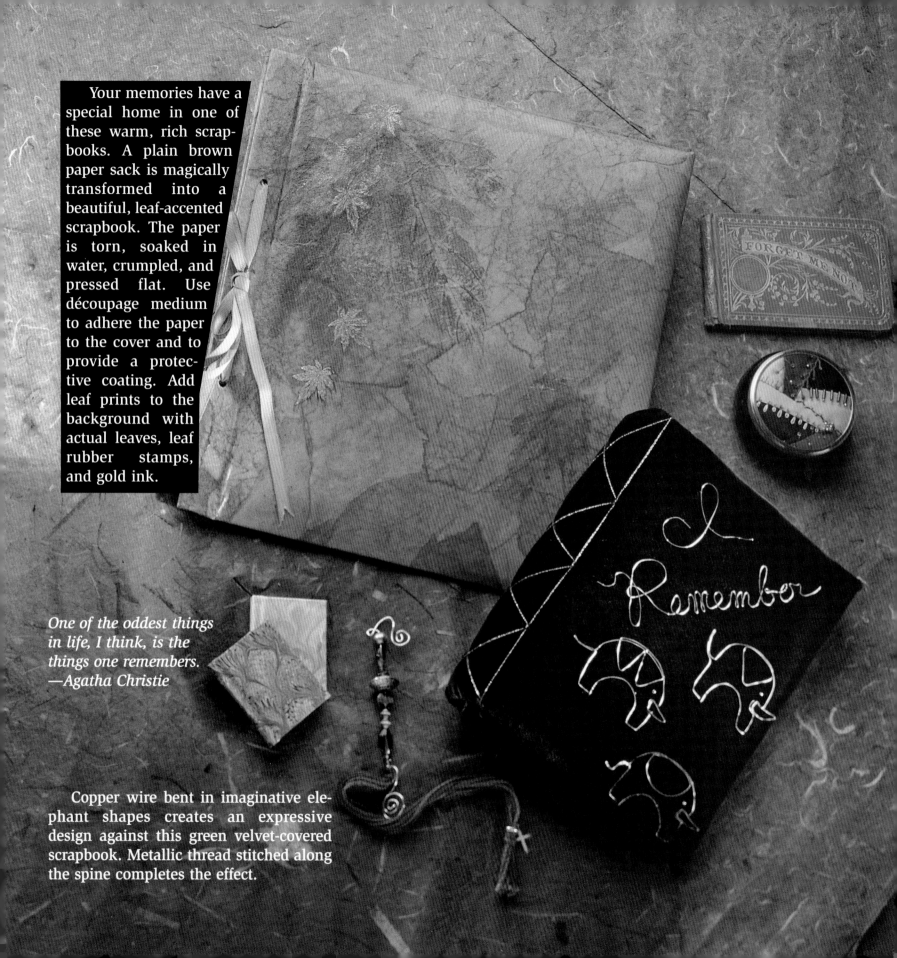

Your memories have a special home in one of these warm, rich scrapbooks. A plain brown paper sack is magically transformed into a beautiful, leaf-accented scrapbook. The paper is torn, soaked in water, crumpled, and pressed flat. Use découpage medium to adhere the paper to the cover and to provide a protective coating. Add leaf prints to the background with actual leaves, leaf rubber stamps, and gold ink.

One of the oddest things in life, I think, is the things one remembers.
—Agatha Christie

Copper wire bent in imaginative elephant shapes creates an expressive design against this green velvet-covered scrapbook. Metallic thread stitched along the spine completes the effect.

Secret gardens of the
heart where the old
stay young forever.
—Judy Collins

54

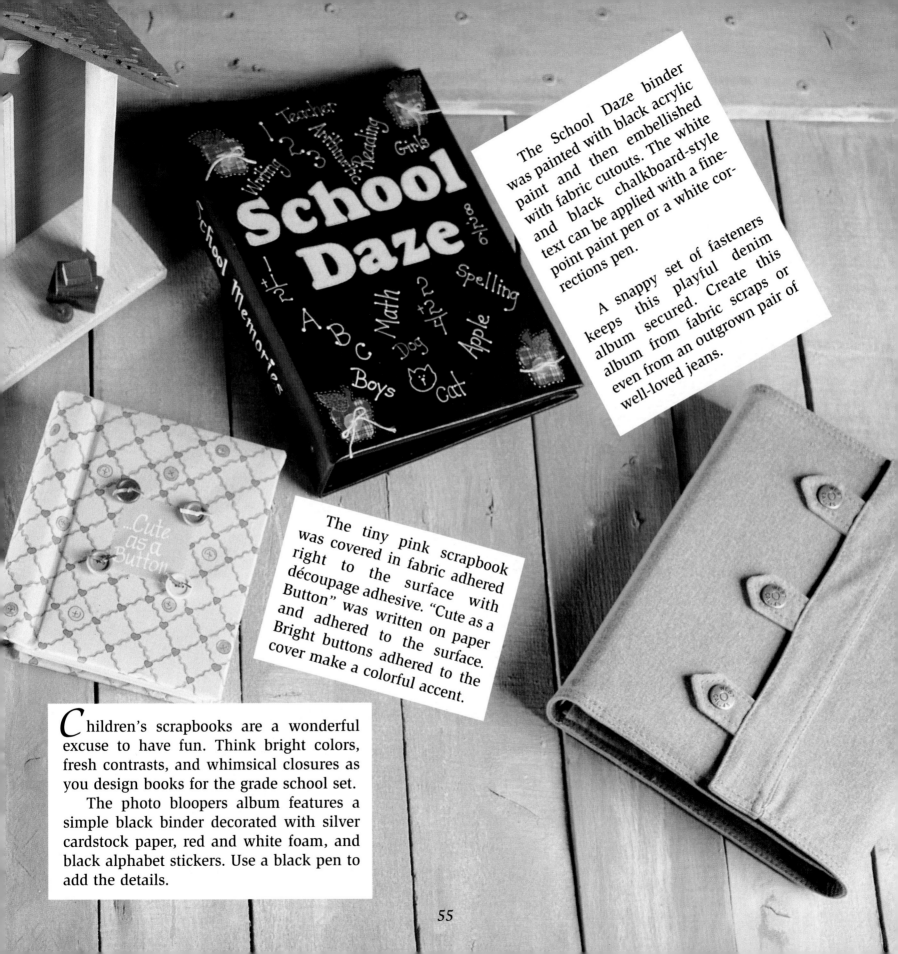

The School Daze binder was painted with black acrylic paint and then embellished with fabric cutouts. The white and black chalkboard-style text can be applied with a fine-point paint pen or a white corrections pen.

A snappy set of fasteners keeps this playful denim album secured. Create this album from fabric scraps or even from an outgrown pair of well-loved jeans.

The tiny pink scrapbook was covered in fabric adhered right to the surface with découpage adhesive. "Cute as a Button" was written on paper and adhered to the surface. Bright buttons adhered to the cover make a colorful accent.

*C*hildren's scrapbooks are a wonderful excuse to have fun. Think bright colors, fresh contrasts, and whimsical closures as you design books for the grade school set.

The photo bloopers album features a simple black binder decorated with silver cardstock paper, red and white foam, and black alphabet stickers. Use a black pen to add the details.

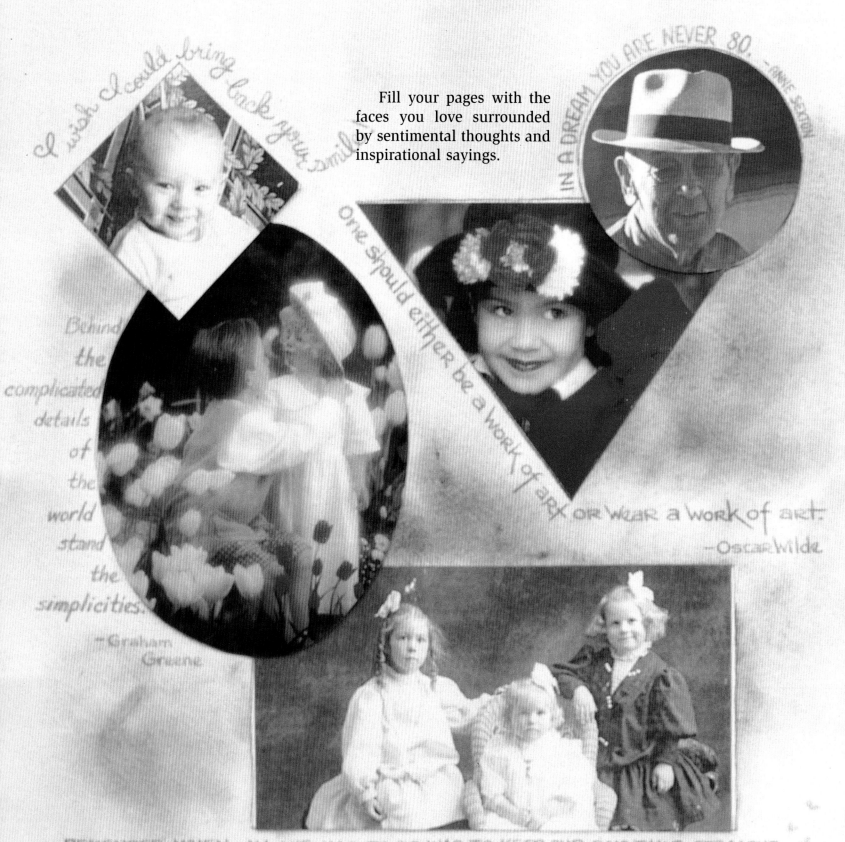

I wish I could bring back your smile

IN A DREAM YOU ARE NEVER 80. —ANNE SEXTON

Fill your pages with the faces you love surrounded by sentimental thoughts and inspirational sayings.

One should either be a work of art, or wear a work of art. —Oscar Wilde

Behind the complicated details of the world stand the simplicities. —Graham Greene

REMEMBER WHEN ALL WE HAD TO DO WAS TO KEEP OUR PONYTAILS STRAIGHT AND CATCH FIREFLIES?

Scrapbook Pages

Once you have designed the perfect album cover, turn your attention to the pages. You can choose a catchy title for each page or caption individual photographs. One of the captions below may fit your photographs or inspire your imagination to make up sayings of your own. The following pages are filled with ways to make your scrapbook pages works of art.

What's a nice girl like you doing in a place like this?

Witching hour

They don't make **moms** like this anymore!

the **Usual** suspects

Wish you were here!

This *hurts* me more than it *hurts* you

They're *playing* our *Song*

What you SEE is what you **get**

A little help from *our* Friends

LAST, BUT NOT LEAST

Tonight's the Night

You can run, but **You** can't **hide**

You can't **take it** with you

a **TOWER** of strength

We are not **amused**

Morning Glories

We have ways of *making* you **talk**

What peaceful hours I once enjoyed! How sweet their memory still!
—William Cooper

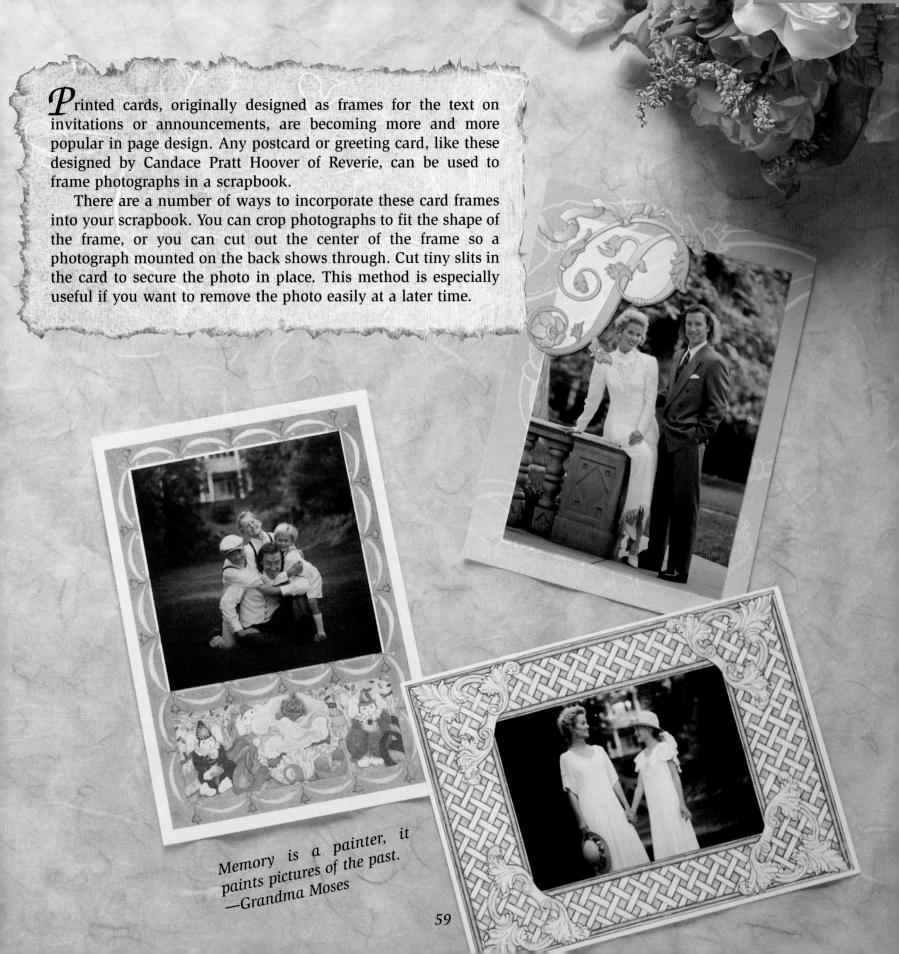

Printed cards, originally designed as frames for the text on invitations or announcements, are becoming more and more popular in page design. Any postcard or greeting card, like these designed by Candace Pratt Hoover of Reverie, can be used to frame photographs in a scrapbook.

There are a number of ways to incorporate these card frames into your scrapbook. You can crop photographs to fit the shape of the frame, or you can cut out the center of the frame so a photograph mounted on the back shows through. Cut tiny slits in the card to secure the photo in place. This method is especially useful if you want to remove the photo easily at a later time.

Memory is a painter, it paints pictures of the past.
—Grandma Moses

Handmade and textured decorative papers add a rich vintage look to scrapbooks, but sometimes special papers are difficult to find or when you do find them they are too expensive to use frequently, or they're not acid-free.

The same rough, aged look found in many specialty papers can be reproduced easily and inexpensively at home using plain cardstock or parchment papers. Paper that has been crumpled and wetted takes on a unique texture that creates a special look.

You must find your own quiet center of life, and write from that.
—Sarah Orne Jewett

Aged Paper

Materials:
Acrylic or watercolor paints
Any type of archival paper
Gloss acrylic varnish (optional)
Gloss découpage medium (optional)
Tools: Large, flat watercolor brush

How To:
Wet paper with a large, flat watercolor brush. Streak paper with a light wash of an acrylic or watercolor paint. Crumple paper into a tight ball, then lay flat to dry. Iron while wet, if desired. Variation: After crumpling, lay paper on a flat surface and rewet with the brush. Arrange the paper in a folded pattern. Dab with a light wash of gloss varnish or découpage medium. Let dry; do not iron.

Families grow up, change—
Traditions change.
We can't hold on to them too
 tightly or they become rigid.
Wait.
New Traditions will happen.
—Madeleine L'Engle

Like hide-and-go-seek—the future curves toward the past then folds back again, seamlessly, always expressing itself in the present tense.
—Tim O'Brien

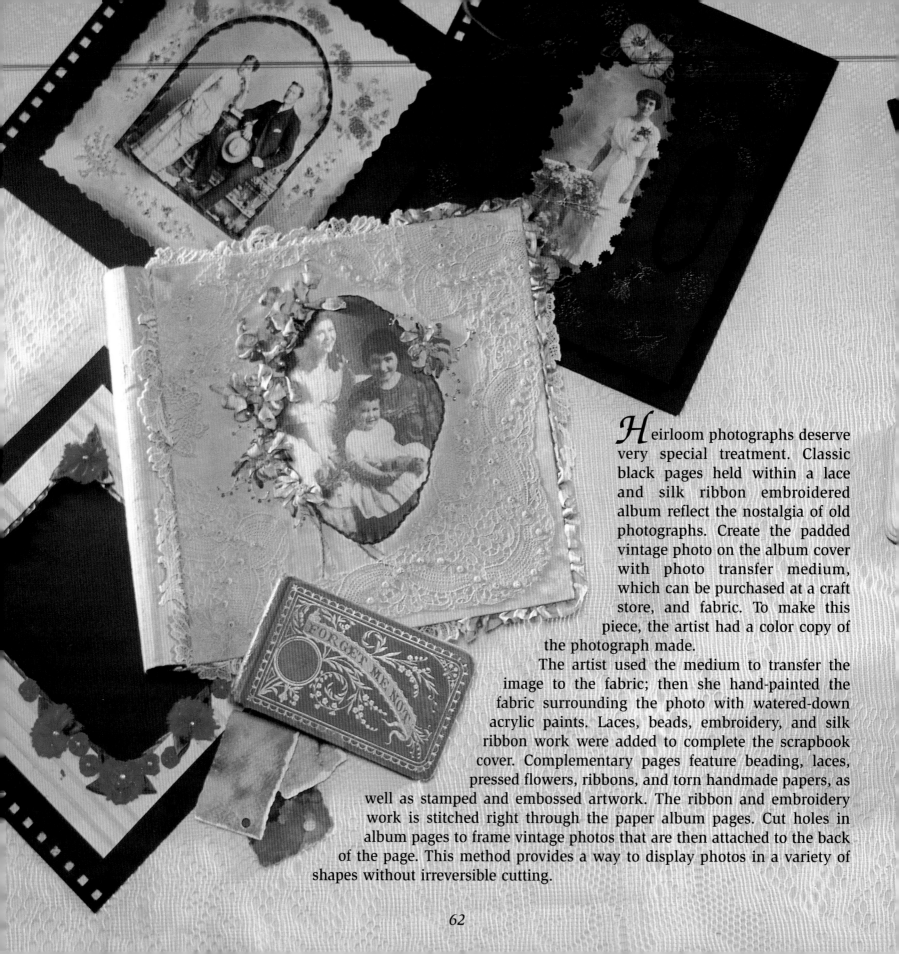

\mathcal{H}eirloom photographs deserve very special treatment. Classic black pages held within a lace and silk ribbon embroidered album reflect the nostalgia of old photographs. Create the padded vintage photo on the album cover with photo transfer medium, which can be purchased at a craft store, and fabric. To make this piece, the artist had a color copy of the photograph made.

The artist used the medium to transfer the image to the fabric; then she hand-painted the fabric surrounding the photo with watered-down acrylic paints. Laces, beads, embroidery, and silk ribbon work were added to complete the scrapbook cover. Complementary pages feature beading, laces, pressed flowers, ribbons, and torn handmade papers, as well as stamped and embossed artwork. The ribbon and embroidery work is stitched right through the paper album pages. Cut holes in album pages to frame vintage photos that are then attached to the back of the page. This method provides a way to display photos in a variety of shapes without irreversible cutting.

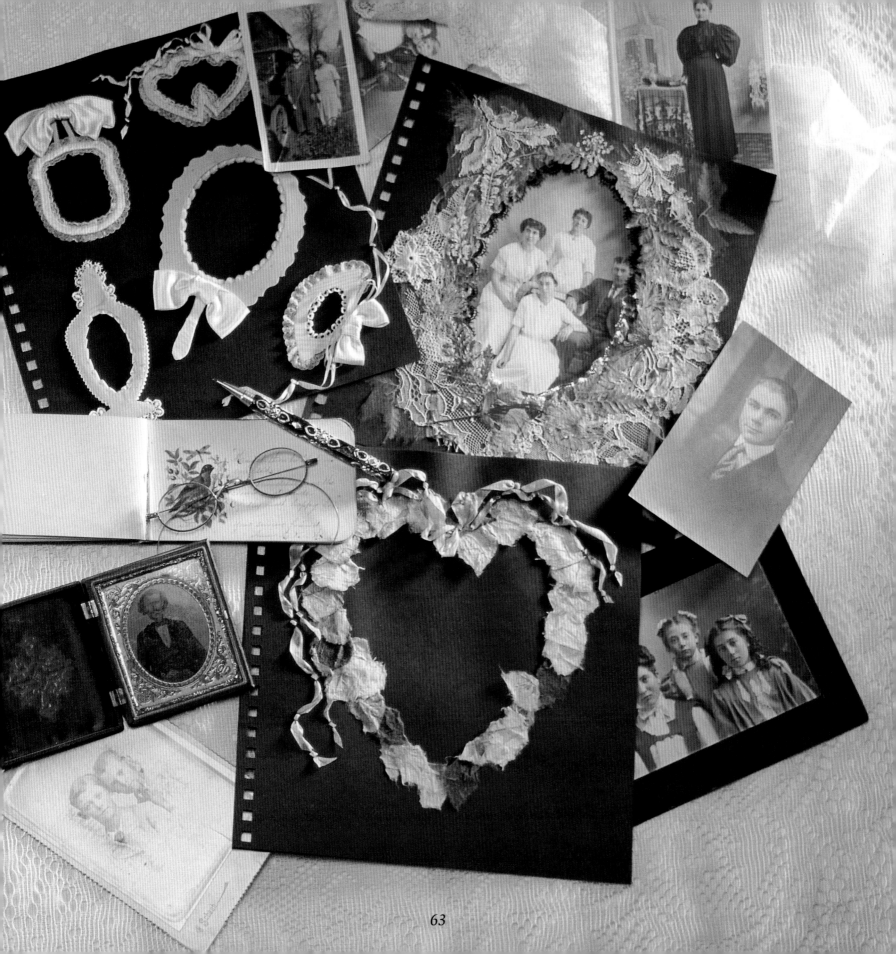

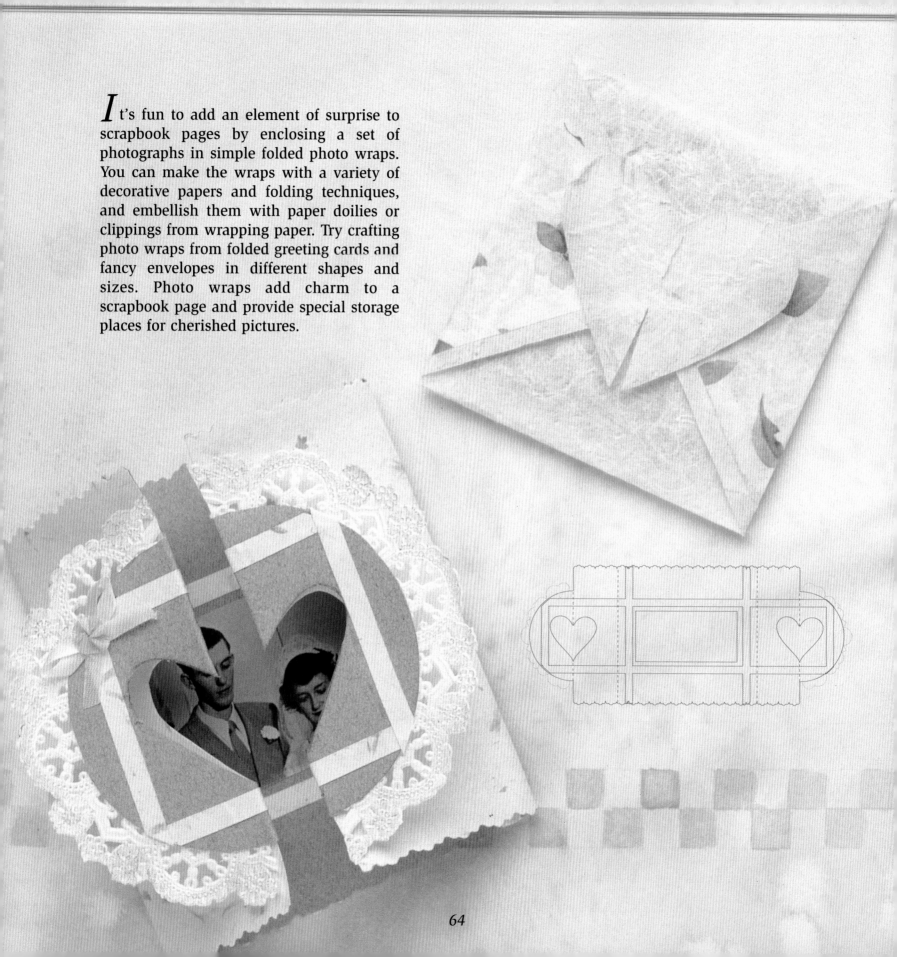

It's fun to add an element of surprise to scrapbook pages by enclosing a set of photographs in simple folded photo wraps. You can make the wraps with a variety of decorative papers and folding techniques, and embellish them with paper doilies or clippings from wrapping paper. Try crafting photo wraps from folded greeting cards and fancy envelopes in different shapes and sizes. Photo wraps add charm to a scrapbook page and provide special storage places for cherished pictures.

The papers used to design photo wraps can be just as sentimental as the photos they protect. Wedding gift wrapping paper, birthday cards, artwork, or even a young child's creative masterpiece make uniquely personal wraps.

The wraps shown on this page are only a handful of the many possibilities. Explore origami books, combine techniques, or experiment on your own to create one-of-a-kind designs.

Love joins our present with the past and the future.
—Kahlil Gibran

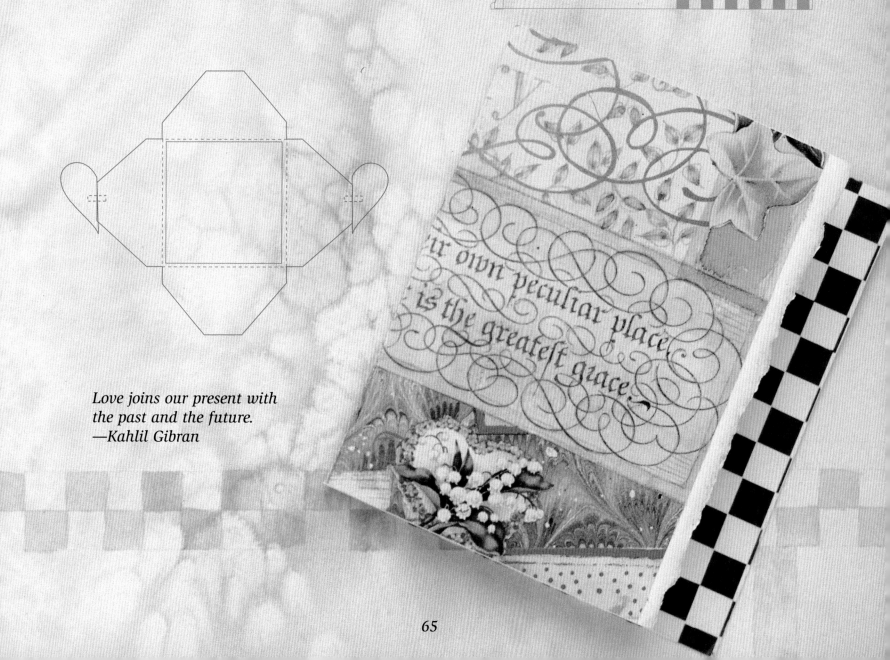

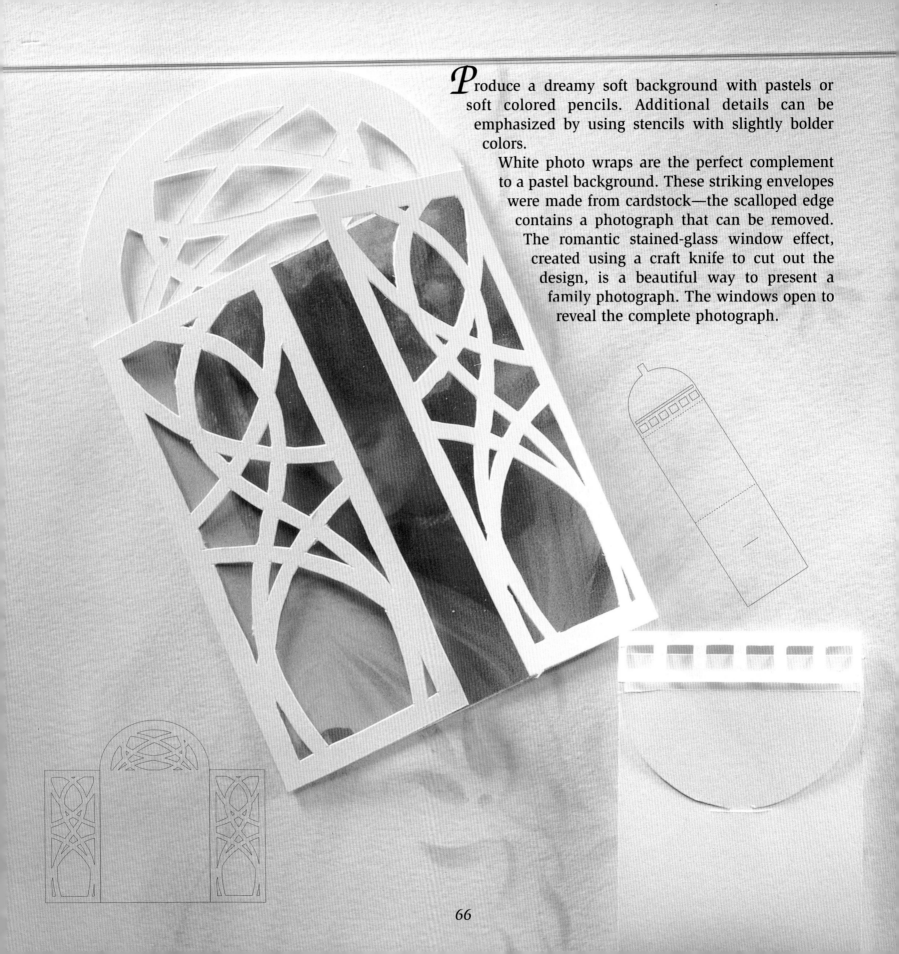

*P*roduce a dreamy soft background with pastels or soft colored pencils. Additional details can be emphasized by using stencils with slightly bolder colors.

White photo wraps are the perfect complement to a pastel background. These striking envelopes were made from cardstock—the scalloped edge contains a photograph that can be removed. The romantic stained-glass window effect, created using a craft knife to cut out the design, is a beautiful way to present a family photograph. The windows open to reveal the complete photograph.

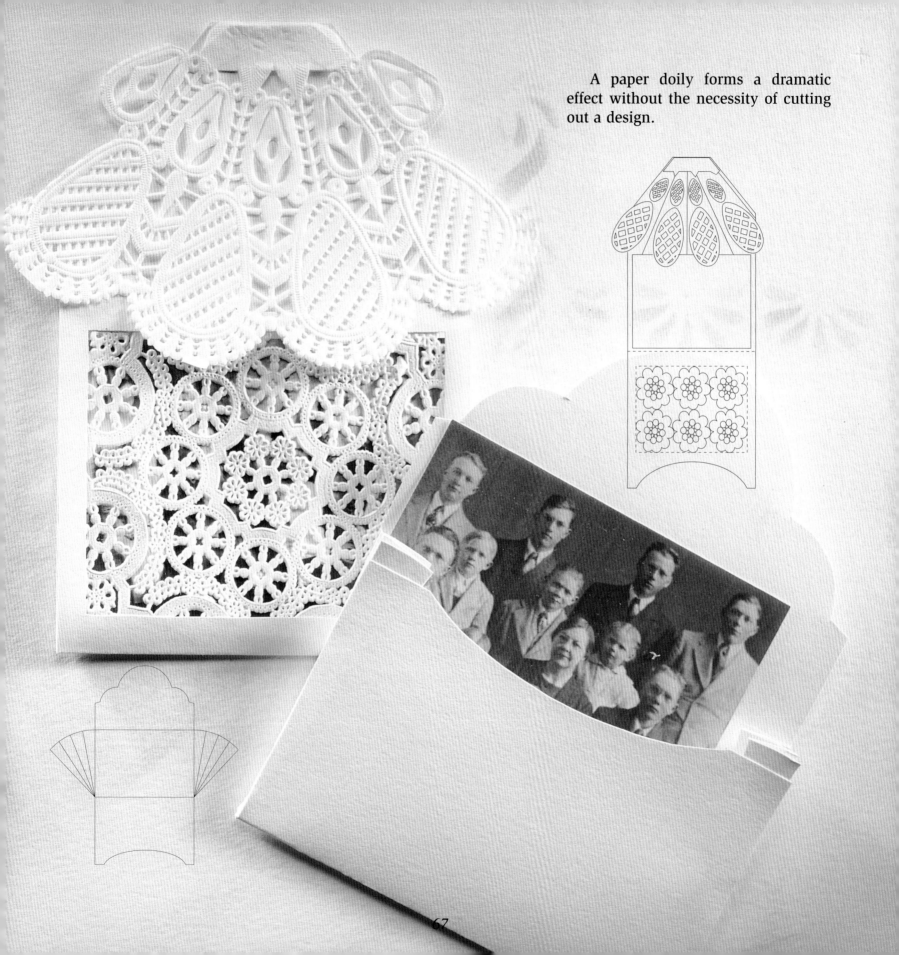

A paper doily forms a dramatic effect without the necessity of cutting out a design.

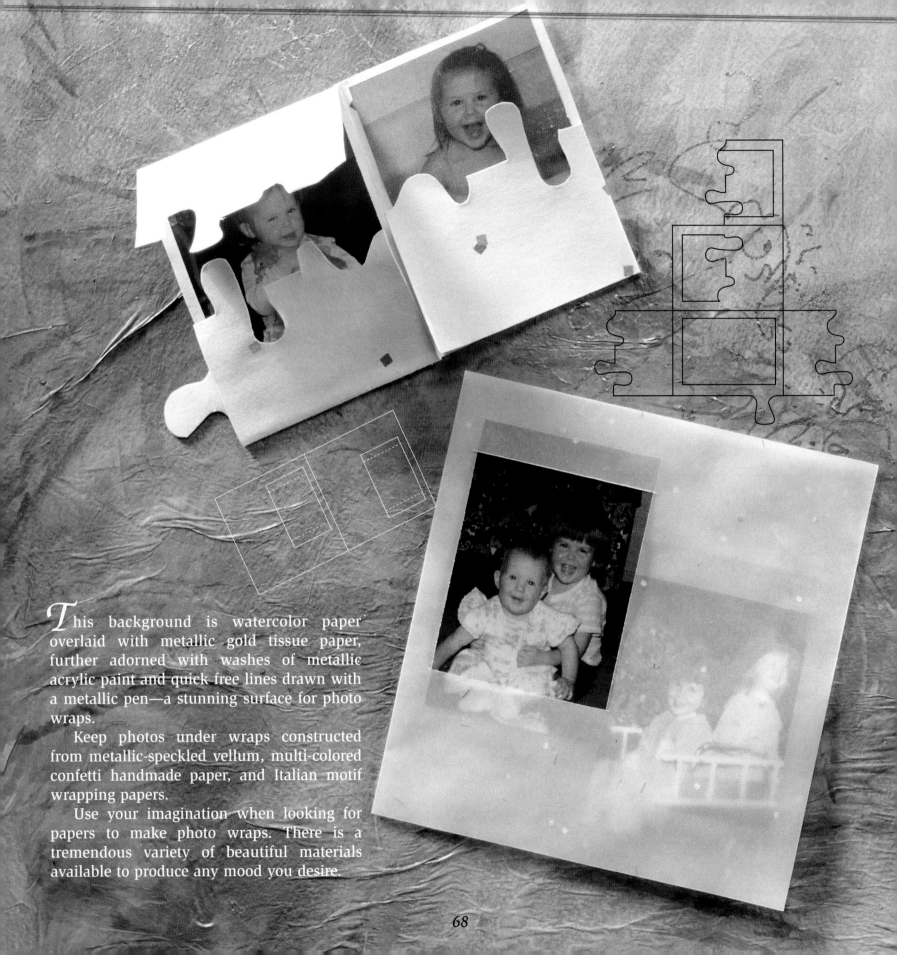

This background is watercolor paper overlaid with metallic gold tissue paper, further adorned with washes of metallic acrylic paint and quick free lines drawn with a metallic pen—a stunning surface for photo wraps.

Keep photos under wraps constructed from metallic-speckled vellum, multi-colored confetti handmade paper, and Italian motif wrapping papers.

Use your imagination when looking for papers to make photo wraps. There is a tremendous variety of beautiful materials available to produce any mood you desire.

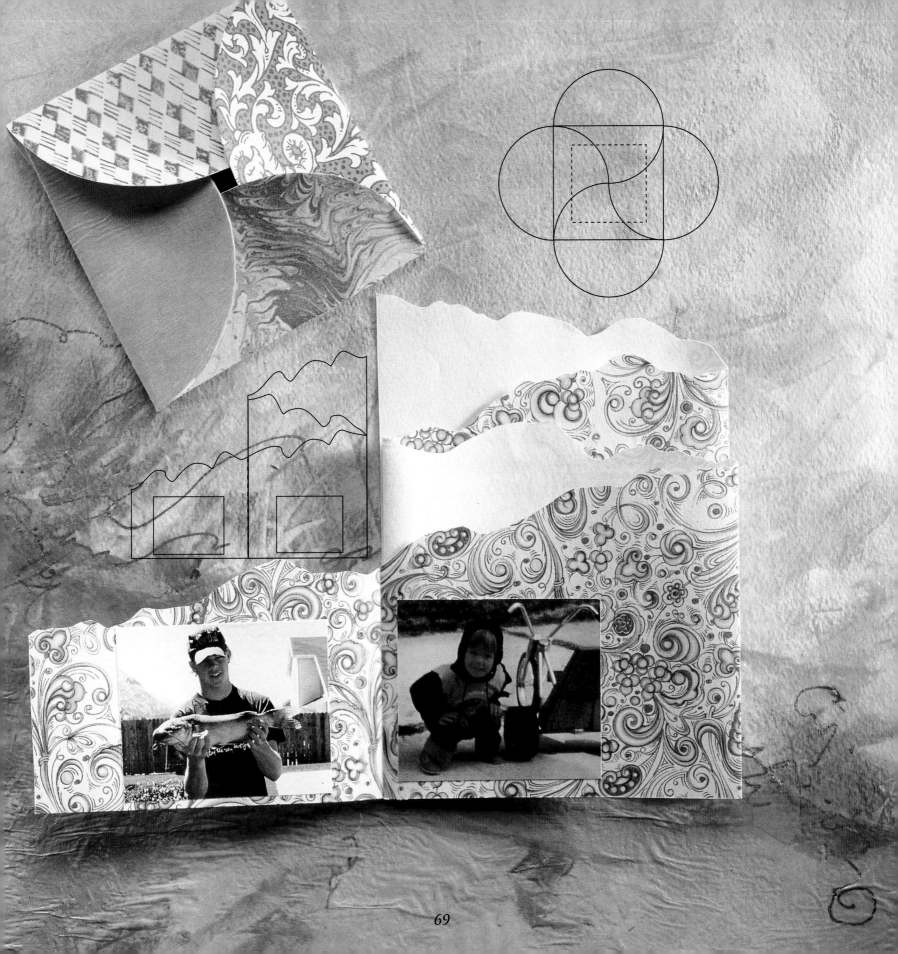

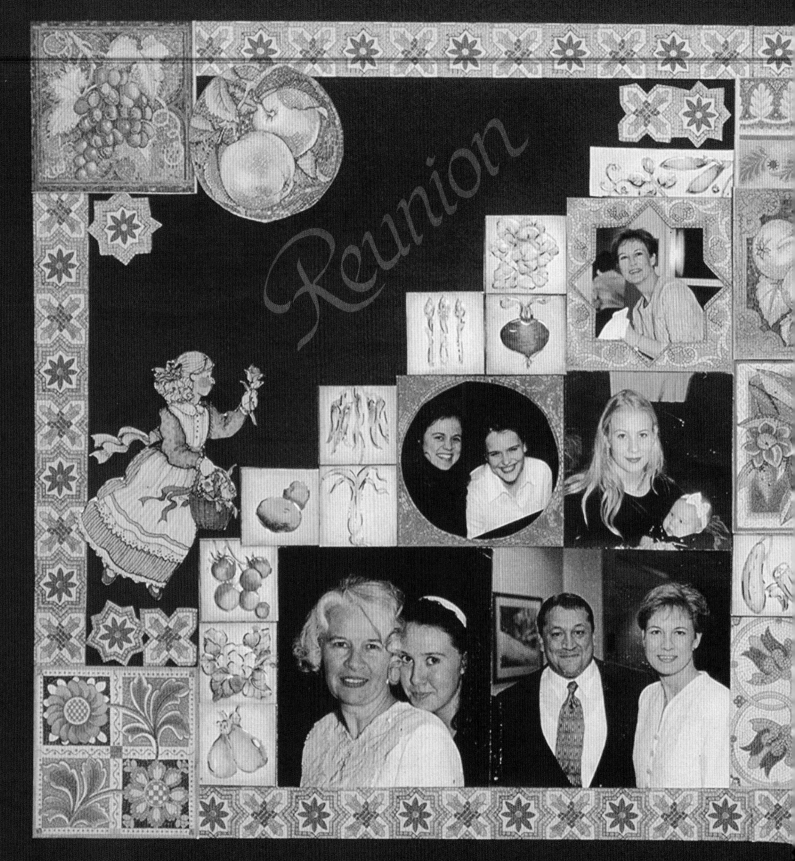

Reunion

A classic quilt design is a beautiful way to capture the joy of a family reunion.

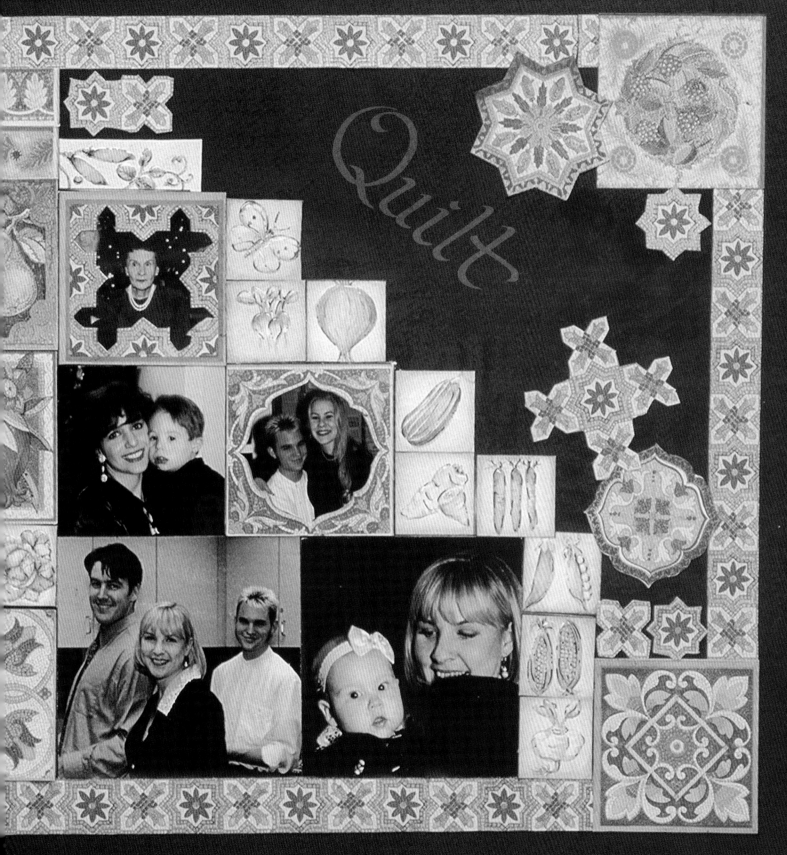

Quilt

Wrapping paper and greeting cards are great sources for design elements.

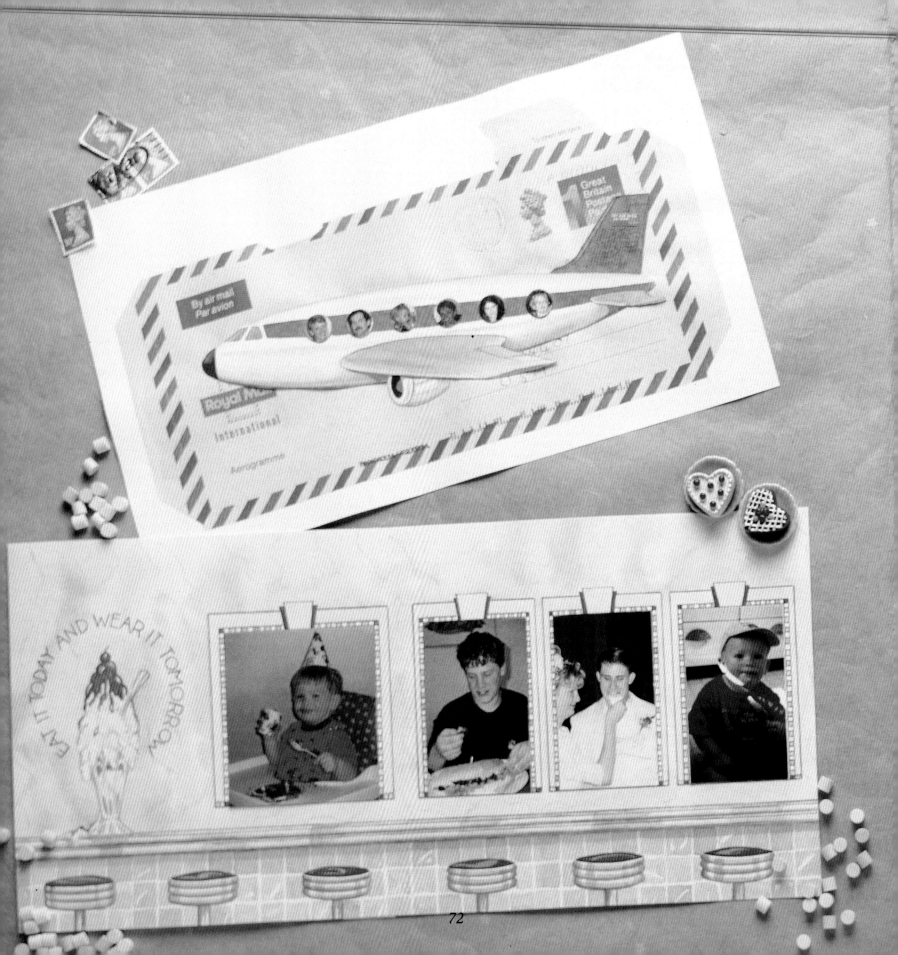

Whimsical watercolors are a fun addition to any scrapbook. Use whatever painting skills you may possess to whip up fanciful artwork for your pages. Keep your designs sweet, simple, and most of all playful. Don't forget to include places to attach your favorite photos. Add a humorous quote or a few funny photos, and your pages are complete. Color-copy your artwork to share or use in other scrapbooks. If you're not much of a painter, cut out images from magazines, mount them on cardstock, and manipulate them creatively to frame or enclose your photos.

Paint an airmail envelope or use commercial stamps, postcards, and airmail envelopes to tell your travel adventures.

Humor is a fanciful way to display and tell a personal story whether it is fun food photos or family "fish tales."

These watercolors are only a few of the many possibilities. Let your creativity run wild and you'll discover many more. A rocket ship filled with kids in costumes, a laundromat featuring men in muddy work clothes, a church with dressed-up family members in each window—the choice is yours. Books, magazines, even junk mail flyers and advertising inserts are rich sources for images to copy or cut out to frame and enhance the story your photos tell.

When you have scrapbook art that turns out this fantastic, you may want to consider framing and displaying the original and placing a color copy in your scrapbook.

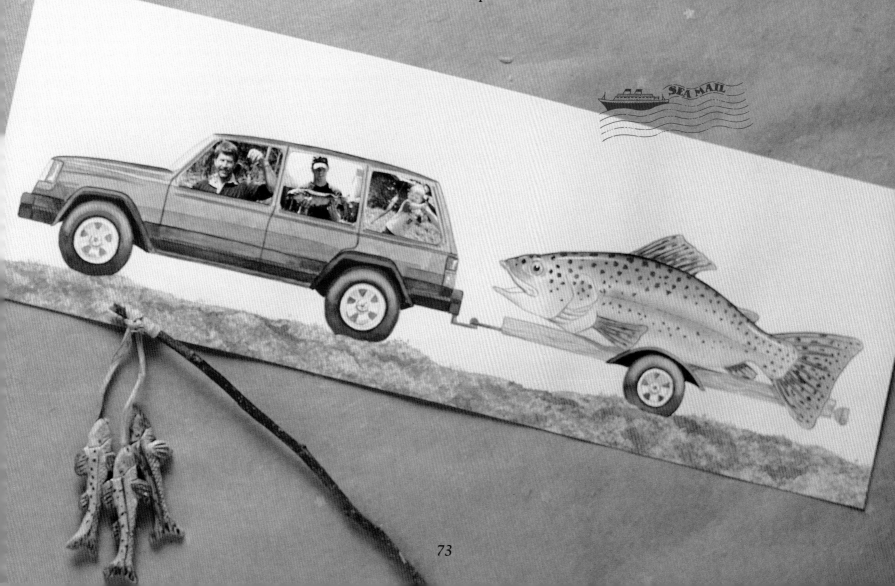

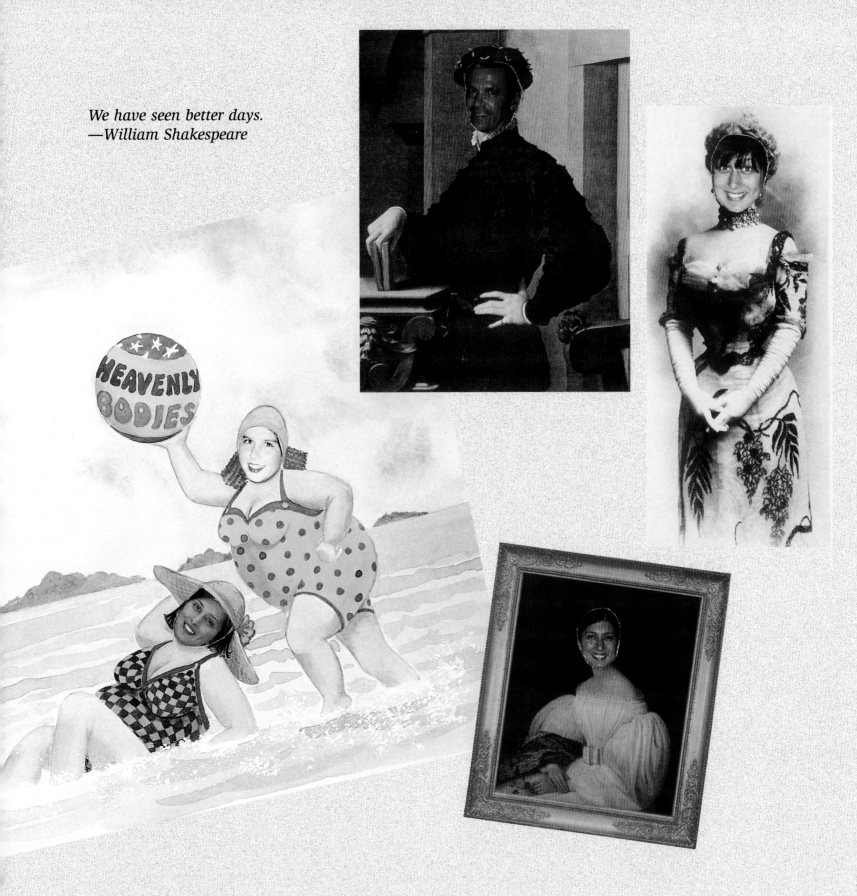

We have seen better days.
—William Shakespeare

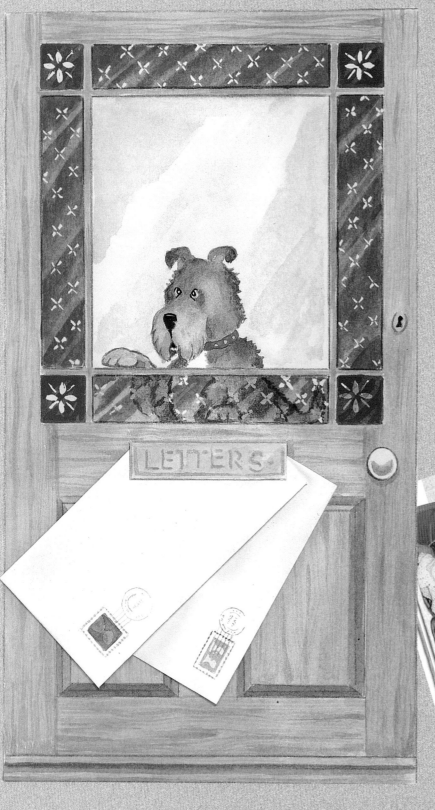

Why forget memories of that first frisky puppy or your favorite playful kitty? You can save those special moments in pages dedicated to your precious pets. You may even create an entire scrapbook to fill with animal antics.

Inspiration for pet scrapbook pages can be found all around, in cartoons, illustrations from a child's book, perhaps in your pet's comical or predictable behavior, like running to the door each time the mail is delivered.

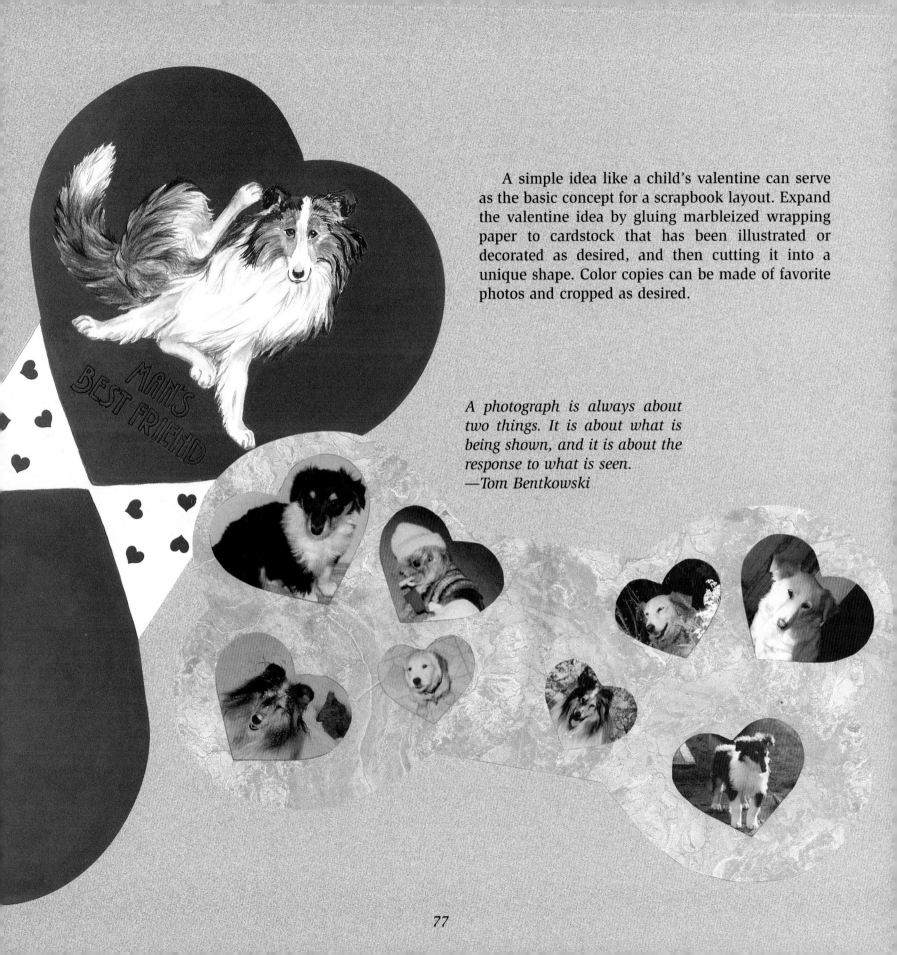

A simple idea like a child's valentine can serve as the basic concept for a scrapbook layout. Expand the valentine idea by gluing marbleized wrapping paper to cardstock that has been illustrated or decorated as desired, and then cutting it into a unique shape. Color copies can be made of favorite photos and cropped as desired.

A photograph is always about two things. It is about what is being shown, and it is about the response to what is seen.
—Tom Bentkowski

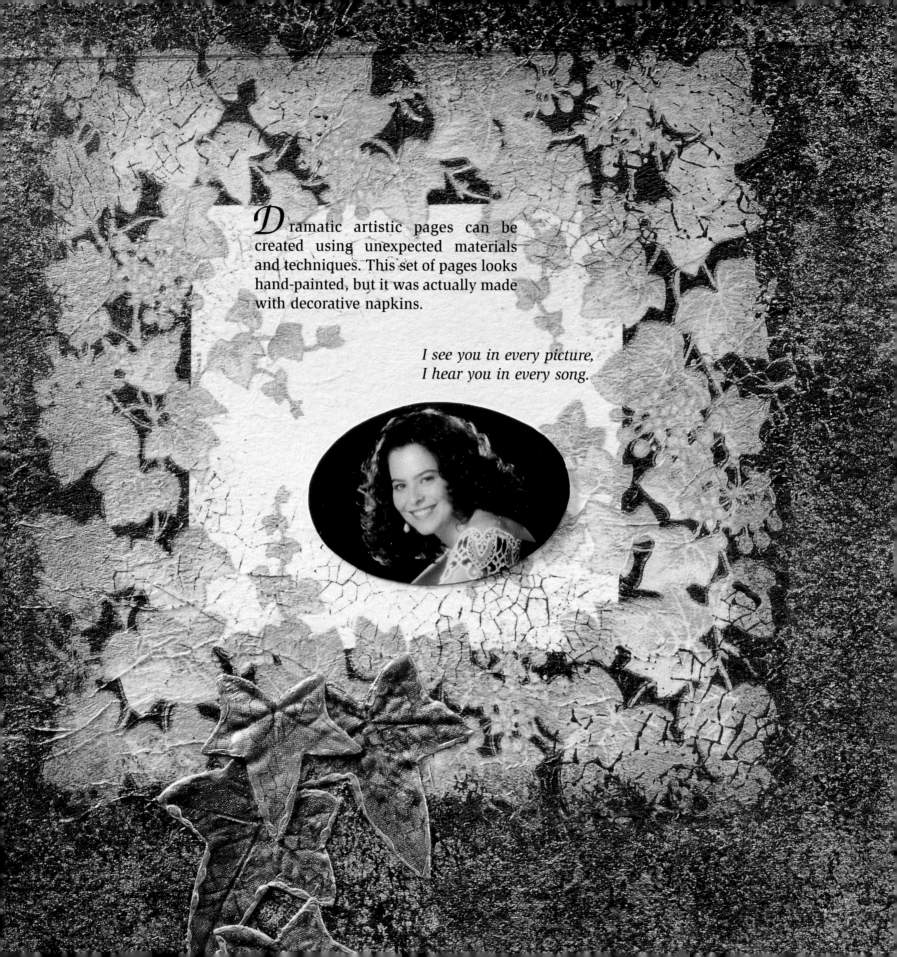

*D*ramatic artistic pages can be created using unexpected materials and techniques. This set of pages looks hand-painted, but it was actually made with decorative napkins.

I see you in every picture,
I hear you in every song.

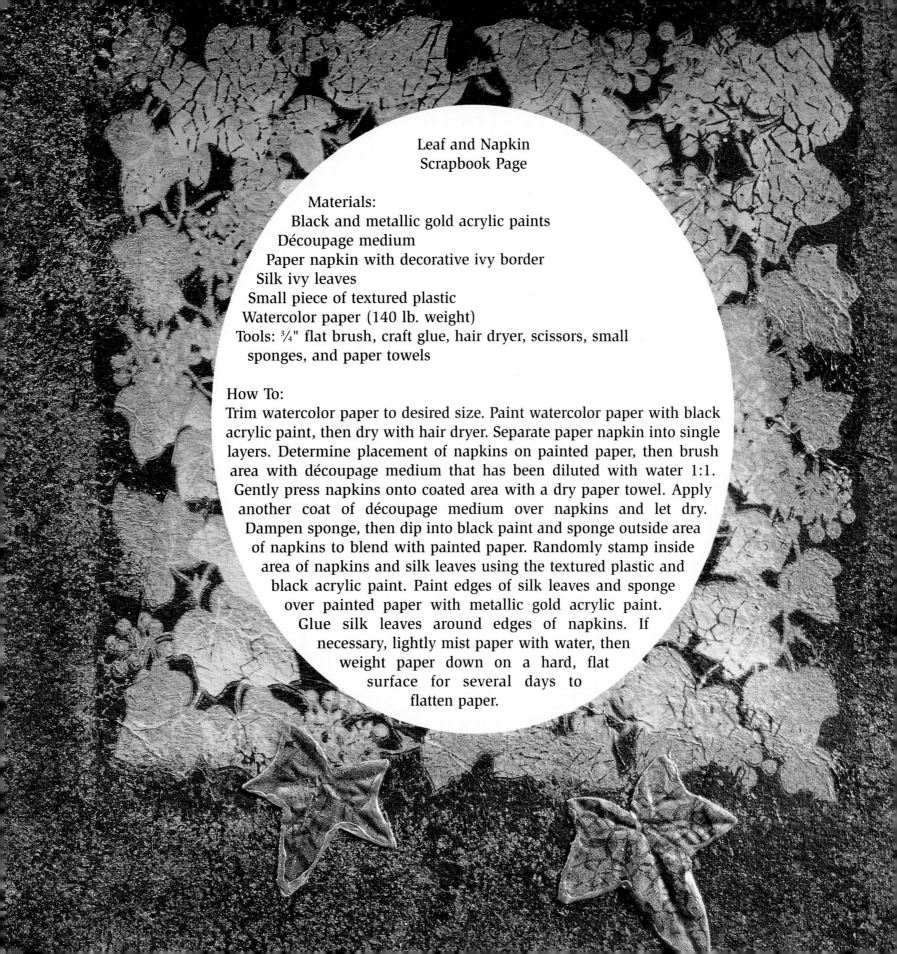

Leaf and Napkin
Scrapbook Page

Materials:
Black and metallic gold acrylic paints
Découpage medium
Paper napkin with decorative ivy border
Silk ivy leaves
Small piece of textured plastic
Watercolor paper (140 lb. weight)
Tools: ¾" flat brush, craft glue, hair dryer, scissors, small
 sponges, and paper towels

How To:
Trim watercolor paper to desired size. Paint watercolor paper with black acrylic paint, then dry with hair dryer. Separate paper napkin into single layers. Determine placement of napkins on painted paper, then brush area with découpage medium that has been diluted with water 1:1. Gently press napkins onto coated area with a dry paper towel. Apply another coat of découpage medium over napkins and let dry. Dampen sponge, then dip into black paint and sponge outside area of napkins to blend with painted paper. Randomly stamp inside area of napkins and silk leaves using the textured plastic and black acrylic paint. Paint edges of silk leaves and sponge over painted paper with metallic gold acrylic paint. Glue silk leaves around edges of napkins. If necessary, lightly mist paper with water, then weight paper down on a hard, flat surface for several days to flatten paper.

*W*arm earth tones combined with the richness of gold produce a fascinating background for this set of scrapbook pages.

Capture the golden spirit of autumn with brown Japanese paper layered with parchment paper. Metallic stampings created with impressions of real leaves are combined with a gold-edged ribbon. A dry brushing of diluted gold acrylic paint gives a glow to the page.

This style of background is particularly effective for vintage sepia-toned photos.

Materials:

1½"-wide brown sheer gold-edged ribbon

Beige/tan parchment paper

Brown, metallic gold, olive green, and light rose acrylic paints

Brown-fibered Japanese paper

Hard plastic with crushed-ice texture

Natural leaves

Watercolor paper (140 lb. weight)

White Japanese tissue paper

Tools: Flat brush, paper adhesive, paper towels, small sponge, and sponge brush

How To:

Trim watercolor paper to desired size. Trim brown-fibered Japanese paper same size as watercolor paper. Apply an even coat of paper adhesive to watercolor paper using a sponge brush. Lay fibered paper onto adhesive surface and gently smooth with a pad of paper towels. Trim parchment paper to fit one half of watercolor paper. Brush an even coat of paper adhesive onto right-hand side of watercolor paper and lay parchment paper onto adhesive surface. Dilute one to two drops of each acrylic paint with one tablespoon of water. Sponge paints onto tissue paper to stain. Allow colors to mix and feather together. Let dry. Tear tissue paper into a rectangle that is slightly smaller than parchment paper. Adhere tissue paper to parchment paper with paper adhesive. Using full-strength acrylic paints, dry-brush a light coat of paints onto leaf. Carefully press leaf, paint side down, onto scraps of stained tissue paper. Carefully remove leaf from paper. Repeat several times until desired number of leaves are created. Using full-strength acrylic paint, dry-brush desired color onto piece of textured plastic. Using plastic as a stamp, apply pattern directly to layered papers. Adhere ribbon to right-hand side of watercolor paper. Gently tear leaves from tissue paper and adhere to paper with adhesive. Leaves may be crunched and pushed together to add texture. Overlap edges for interest. Sponge-paint entire surface with gold metallic paint. Let dry.

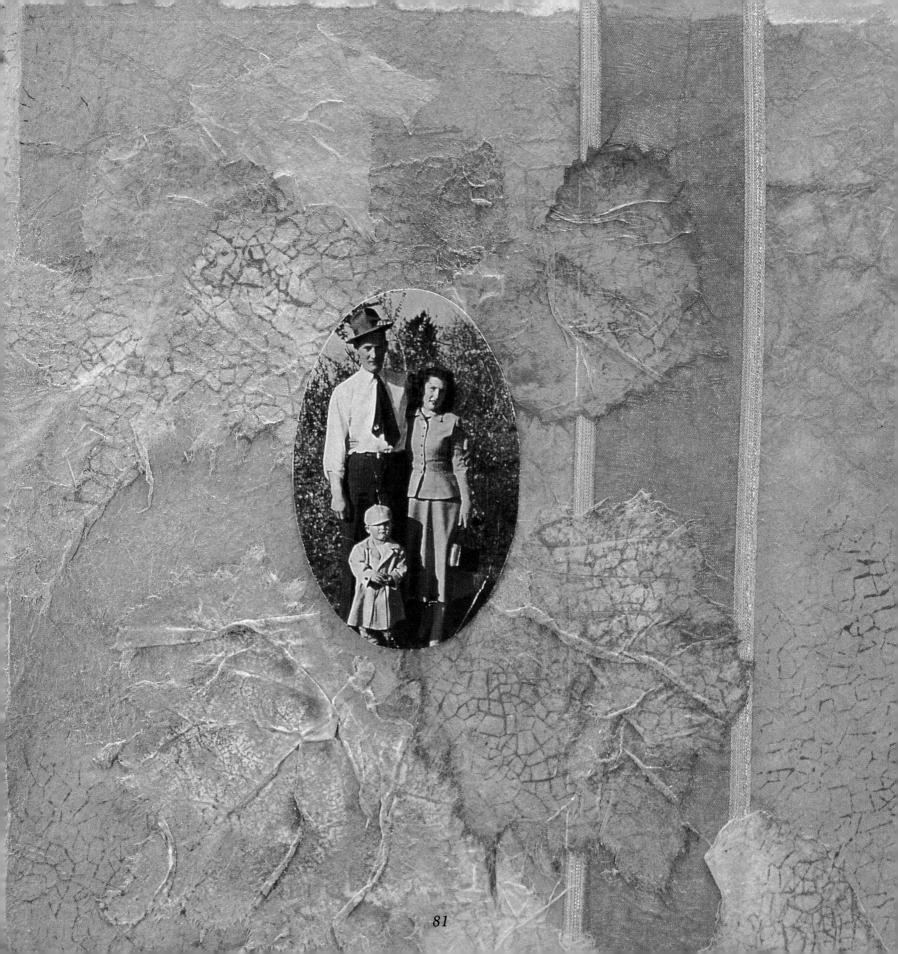

Layered sheer Japanese papers are only a part of the gentle tranquility in this set of pages. Real leaves are used to stamp a leaf impression on thin oriental paper. These paper leaves are layered with lacy scalloped paper over a warm pastel background. Rubber-stamped leaves are added for contrast. A light dry-brush of metallic acrylic paint is feathered over the top as a final touch.

Pastel Lace Paper Scrapbook Page

Materials:
1½"-wide gold-edged organza ribbon
2–3 fresh 4" leaves
Fan-patterned lace paper
Metallic gold embossing powder
Metallic gold, lavender, medium rose, turquoise, and yellow acrylic paints
Small piece of textured plastic
Watercolor paper (140 lb. weight)
White Japanese paper
Tools: 1" flat brush, craft knife, heat tool, leaf rubber stamp, paper adhesive, paper towels, ruler, and tapestry needle

How To:
Trim watercolor paper to desired size using a craft knife and ruler. Dilute each acrylic paint with water 1:5. Brush paper with water until surface glistens. Drag brush across a paper towel to remove excess moisture, then dip into a paint. Touch brush and paint to wet surface of paper at paper's top edge. Pull paint from top to bottom of page. The wetter the paper, the softer and more feathery the brush strokes will appear. If the paper dries too quickly, rinse brush, add more water to paper, and repeat process. Let dry. Rinse leaves in clean water. Pat dry with paper towel. Place leaf, vein side up, and brush lightly with undiluted acrylic paint. The paint will bead on part of the leaf surface but will catch on the vein areas. Tear a piece of Japanese paper approximately the same size as the leaf. Place the paper over the leaf and gently press with a pad of paper towels. Let dry. Trace outline of leaf using a paintbrush and clear water. Pull excess paper away from leaf shape using a tapestry needle and leaving a feathered edge. Following

manufacturer's instructions, stamp and emboss small leaf shapes onto Japanese paper. Color may be added by touching a small amount of diluted paint to nonembossed areas. Repeat process for remaining leaves. Using a dry brush and undiluted acrylic paint, brush a light layer of paint over rough side of textured plastic. Press pieces of Japanese paper onto painted area. Remove. Let dry. Adhere ribbon to paper using paper adhesive. Tear pieces of fan-patterned lace paper into random shapes. Layer and adhere paper pieces to page by brushing adhesive onto paper and pressing the papers into the glued areas.

General Hints: All paper, including water-color paper, will "buckle" or have hills and valleys in it when wet. To alleviate this once the page is completed, but before the photographs are added, lightly mist the front and back of the page with clear water from a spray bottle. Fold a piece of waxed paper and slip the dampened page inside. Weight evenly for two to three days to flatten and dry.

\mathscr{A} whisper-thin layer of metallic flecked Japanese paper was used here to cover a hand-watercolored page. This treatment would be beautiful as a veil for any type of artwork, original or reproduced. Try layering paper over decorative wrapping paper, a favorite print or poster, or even a scrap of wallpaper. The possibilities are endless.

Blue Leaves Scrapbook Page

Materials:
Gold and silver metallic fleck sheer Japanese tissue paper
Leaf patterned wallpaper
Maple leaf and lattice patterned lace paper
Watercolor paper (140 lb. weight)
Tools: 1" flat brush, craft knife, paper towels, paper adhesive,
 small kitchen sponge, ruler, and spray bottle

How To:
Trim watercolor paper, wallpaper, and sheer tissue 1" larger all around than desired page size. Tear lace papers into random shapes. If wallpaper is prepasted, generously sponge back side of paper with water and let sit for several minutes. As prepasted areas soften, rub gently with sponge, rinse sponge, and repeat process to remove as much of the wallpaper paste as possible. With sponge and clean water, dampen front and back of watercolor paper. Brush a liberal amount of paper adhesive to front side of watercolor paper. Place damp artwork onto adhesive on watercolor paper. Smooth gently with a pad of paper towels, from the center of the sheet to the edges. With a clean brush, apply paper adhesive to artwork design. Press lace paper shapes onto adhesive, adding more adhesive as necessary. Lightly brush paper adhesive over entire surface of layered papers. Mist lightly with spray bottle. Lay sheet of tissue paper over paper surface. Pat gently with paper towels to adhere. Do not rub. After paper has been flattened with weights and dried, trim edges to desired size.

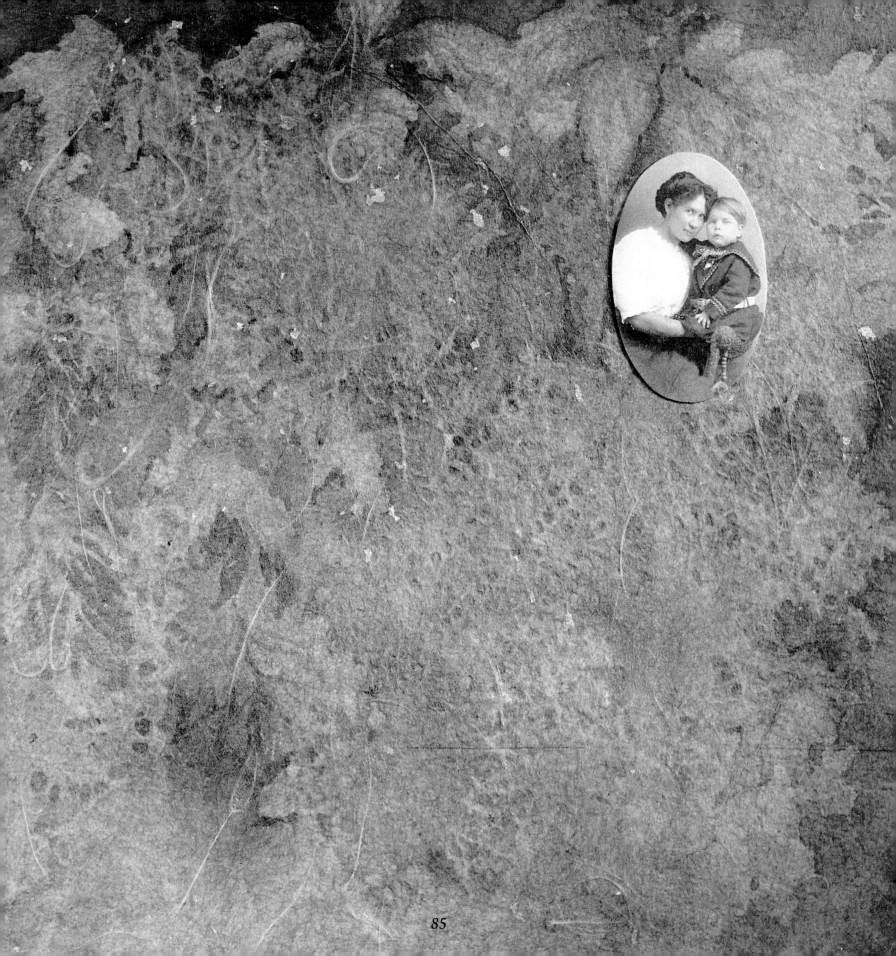

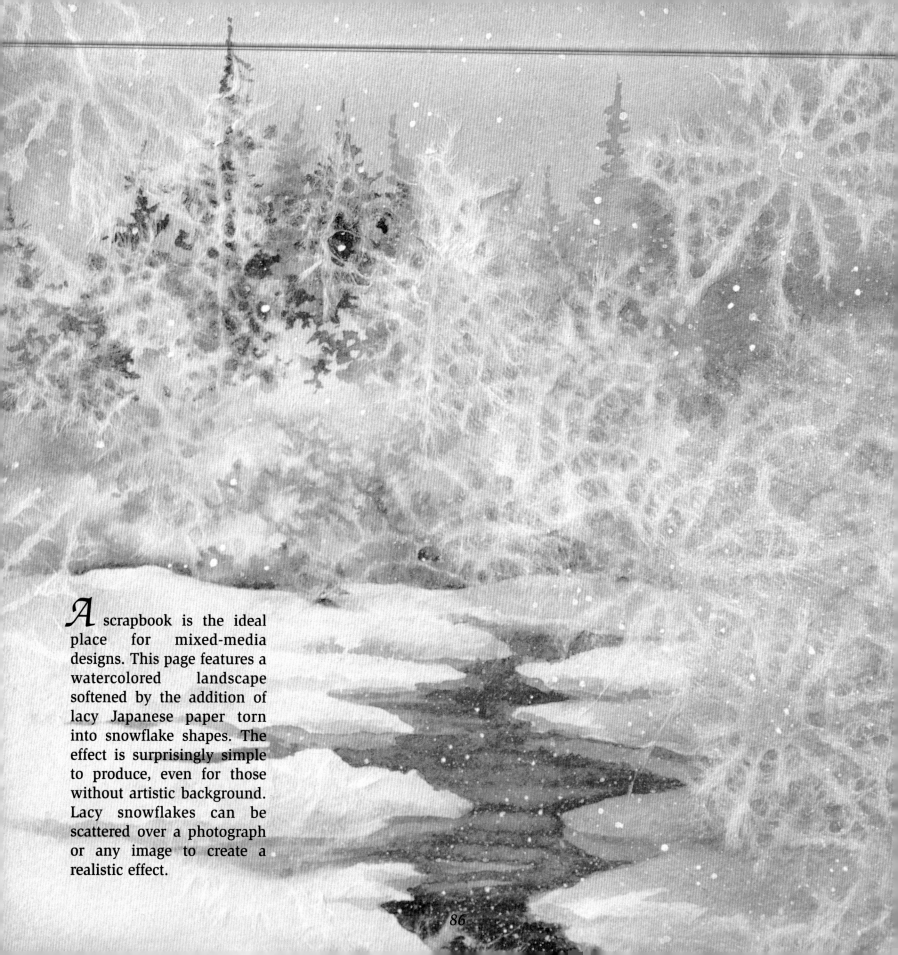

A scrapbook is the ideal place for mixed-media designs. This page features a watercolored landscape softened by the addition of lacy Japanese paper torn into snowflake shapes. The effect is surprisingly simple to produce, even for those without artistic background. Lacy snowflakes can be scattered over a photograph or any image to create a realistic effect.

Winter Scene Scrapbook Page

Materials:
Snowflake and maple leaf patterned lace paper
Watercolor paper (140 lb. weight)
Winter print
Tools: 1" flat brush, craft knife, paper adhesive, and ruler

How To:
Trim watercolor paper to size of print using a craft knife and ruler. Brush a generous layer of paper adhesive to watercolor paper. Adhere print to paper. Gently pull individual pattern pieces from single-ply patterned lace paper. Brush a thin layer of paper adhesive to areas of print where lace paper is desired. Press lace paper into adhesive, working small areas at a time. When lace paper application is completed, brush a light layer of paper adhesive over entire surface to seal and protect. Let dry completely.

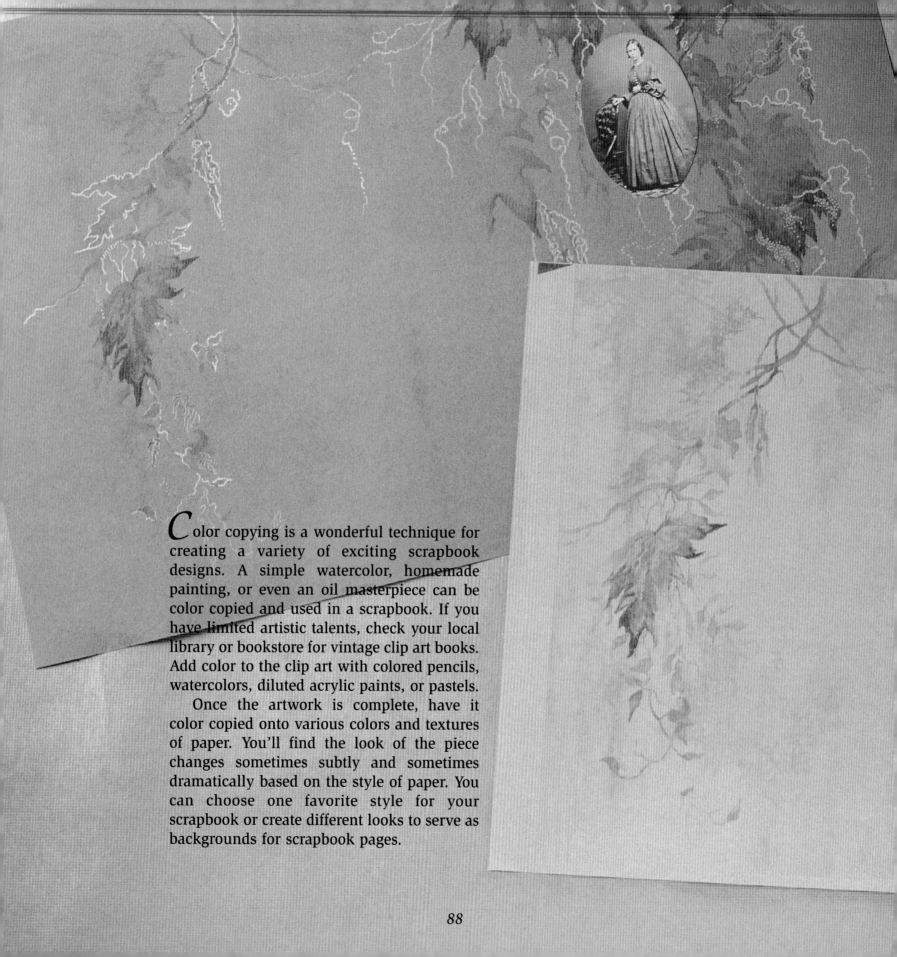

*C*olor copying is a wonderful technique for creating a variety of exciting scrapbook designs. A simple watercolor, homemade painting, or even an oil masterpiece can be color copied and used in a scrapbook. If you have limited artistic talents, check your local library or bookstore for vintage clip art books. Add color to the clip art with colored pencils, watercolors, diluted acrylic paints, or pastels.

Once the artwork is complete, have it color copied onto various colors and textures of paper. You'll find the look of the piece changes sometimes subtly and sometimes dramatically based on the style of paper. You can choose one favorite style for your scrapbook or create different looks to serve as backgrounds for scrapbook pages.

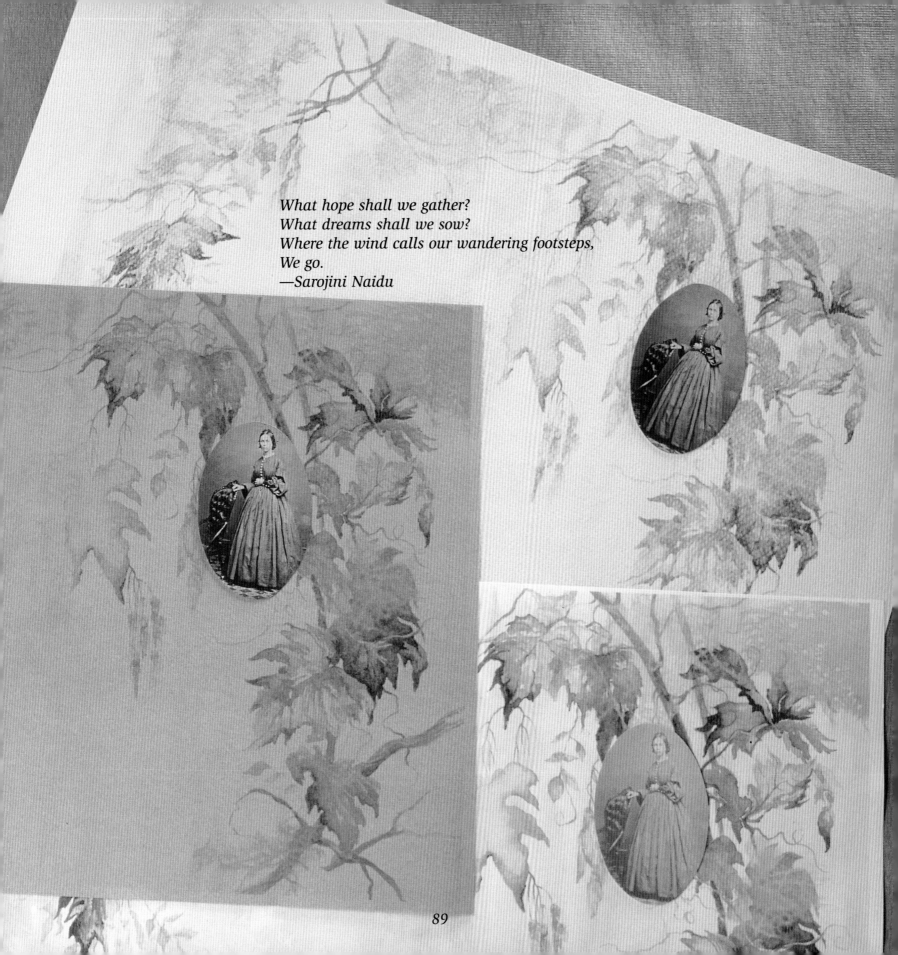

What hope shall we gather?
What dreams shall we sow?
Where the wind calls our wandering footsteps,
We go.
—Sarojini Naidu

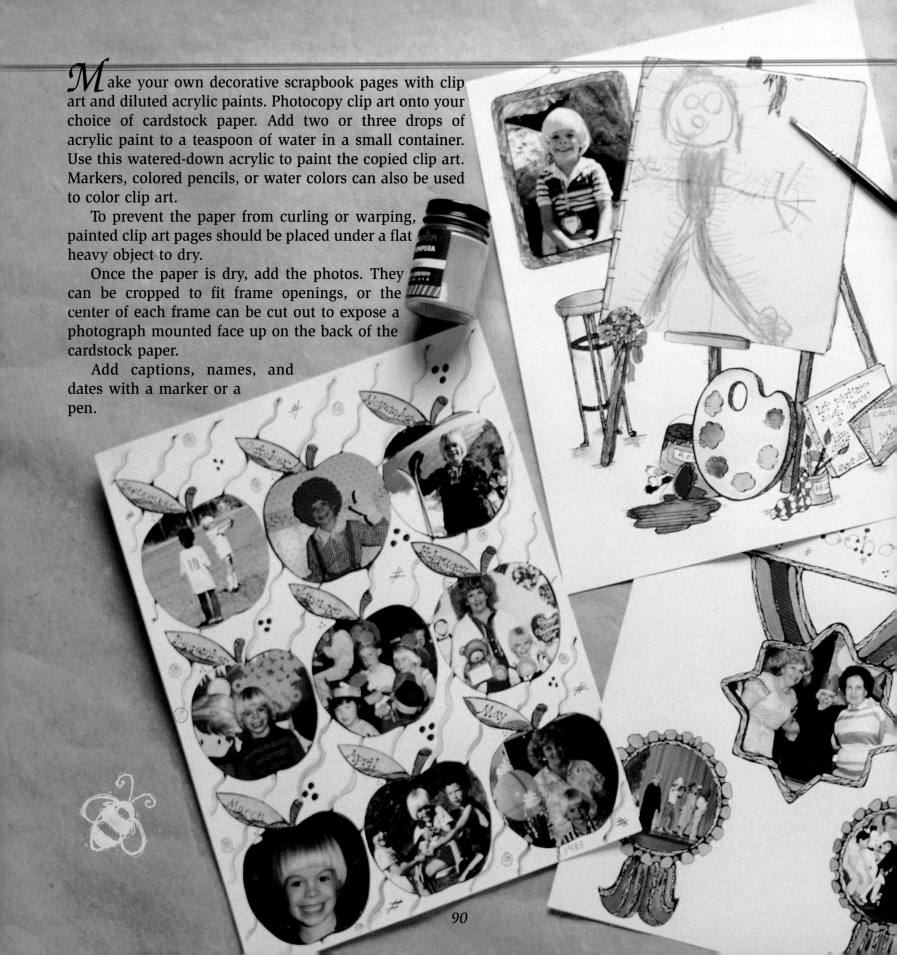

Make your own decorative scrapbook pages with clip art and diluted acrylic paints. Photocopy clip art onto your choice of cardstock paper. Add two or three drops of acrylic paint to a teaspoon of water in a small container. Use this watered-down acrylic to paint the copied clip art. Markers, colored pencils, or water colors can also be used to color clip art.

To prevent the paper from curling or warping, painted clip art pages should be placed under a flat heavy object to dry.

Once the paper is dry, add the photos. They can be cropped to fit frame openings, or the center of each frame can be cut out to expose a photograph mounted face up on the back of the cardstock paper.

Add captions, names, and dates with a marker or a pen.

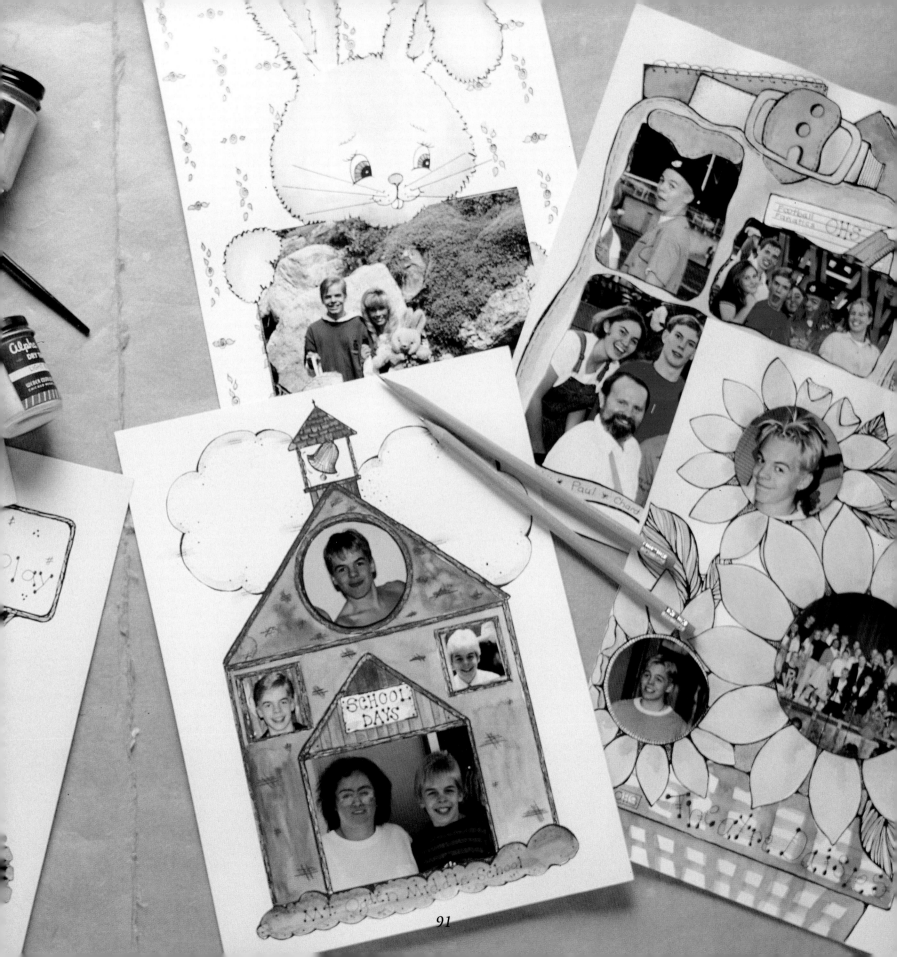

Beyond Traditional Scrapbooks

Forget not that the earth delights to feel your bare feet and the winds long to play with your hair

Memories are the tiny seeds from which the future grows.

When autumn's chilly winds darken your flower garden, photographs are not the only way to capture summer's glory. Take a few moments to gather and press the finest blooms and preserve the promise of spring throughout the cold winter.

Mounted on handmade paper and mingled with thoughts about the earth's beauty, natural treasures enhance a nature lover's scrapbook over the years. A

journal filled with natural memories provides confirmation of earth's renewal whenever the cold winds blow.

A garden is only one place to look for natural scrapbook memories. Gather plants on a woodland hike, save small flat shells from the beach, or collect leaves from an annual mountain camping trip.

You can also commemorate other seasons—keep fall leaves, spring blossoms, or even tiny sprigs of Christmas holly. Artistic scrapbook designers may choose to sketch the glories of nature as well as collect them.

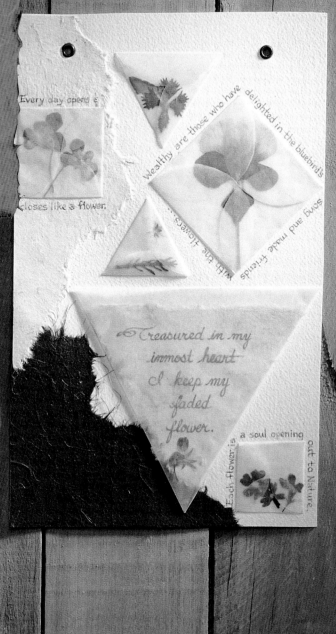

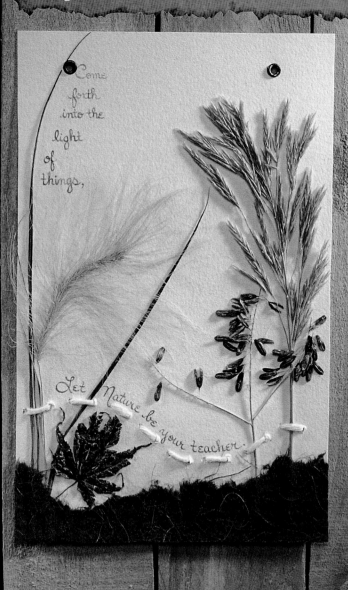

I love the flowers, happy hours lie
Shut up within their petals close and fast:
You have forgotten, dear, but they and I
Keep every fragment of the golden past.
- Adelaide A. Procter

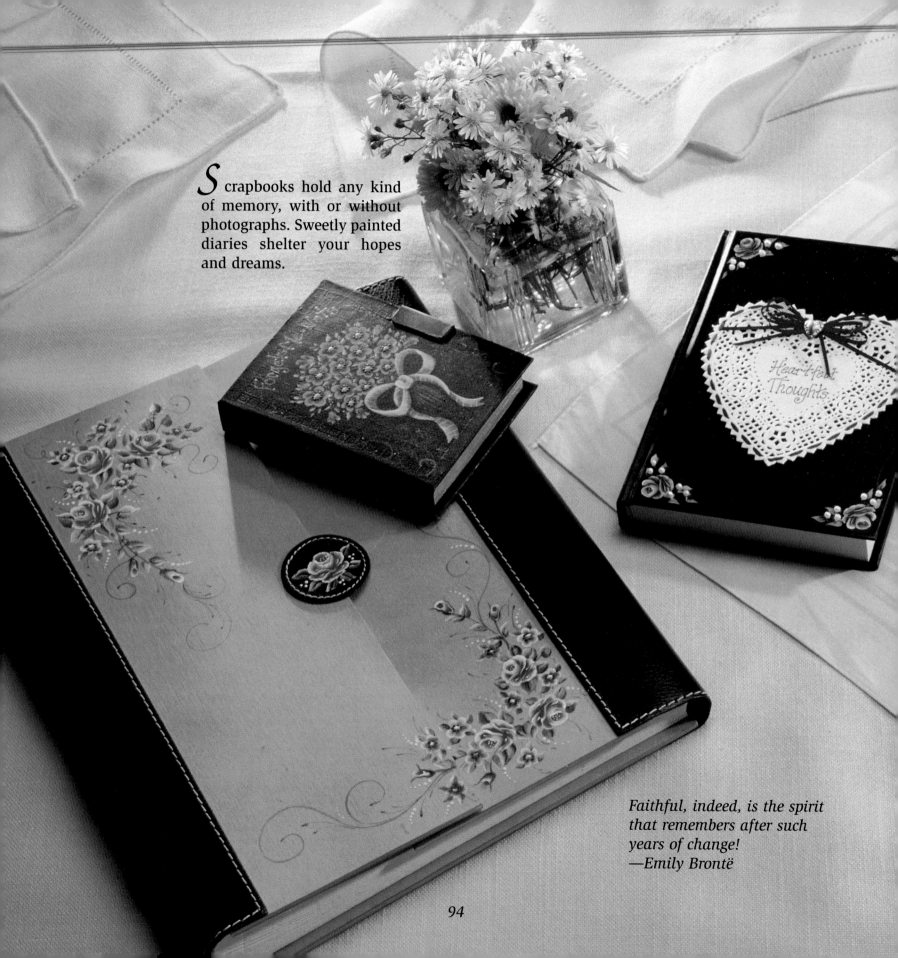

*S*crapbooks hold any kind of memory, with or without photographs. Sweetly painted diaries shelter your hopes and dreams.

Faithful, indeed, is the spirit that remembers after such years of change!
—Emily Brontë

94

Jot down favorite quotes in a heartfelt journal, or keep all Grandma's best recipes in a hand-painted book dedicated to family culinary delights.

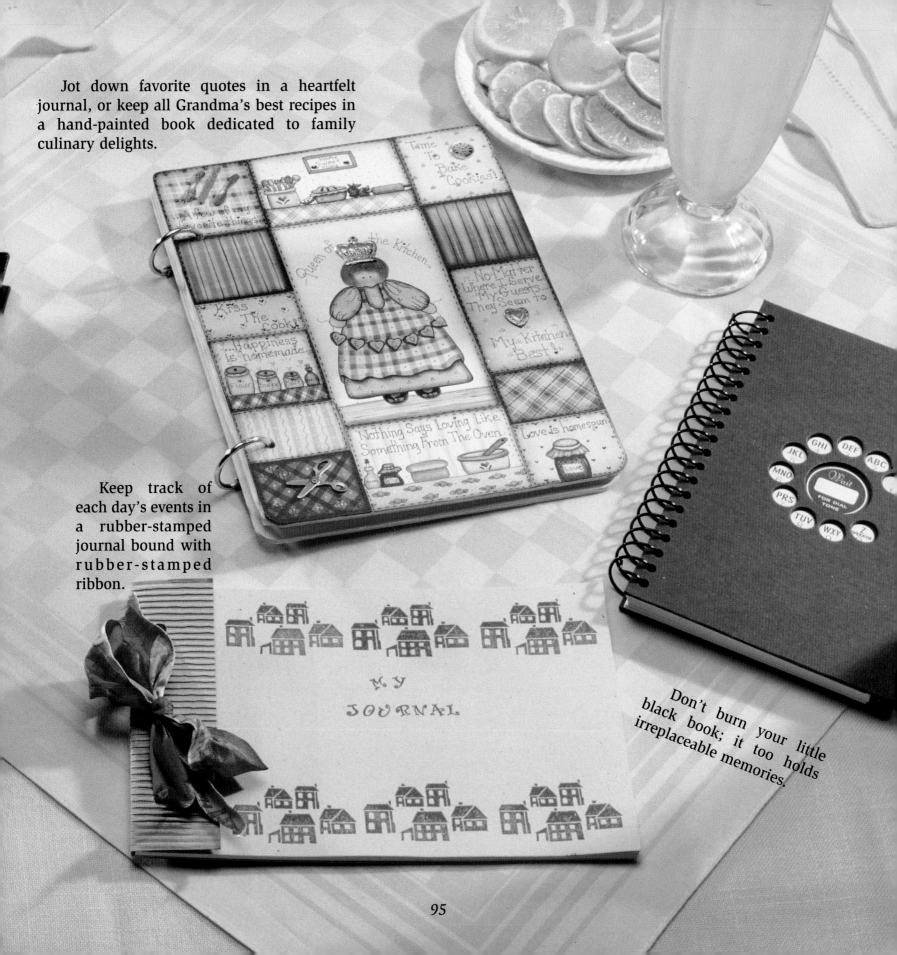

Keep track of each day's events in a rubber-stamped journal bound with rubber-stamped ribbon.

Don't burn your little black book; it too holds irreplaceable memories.

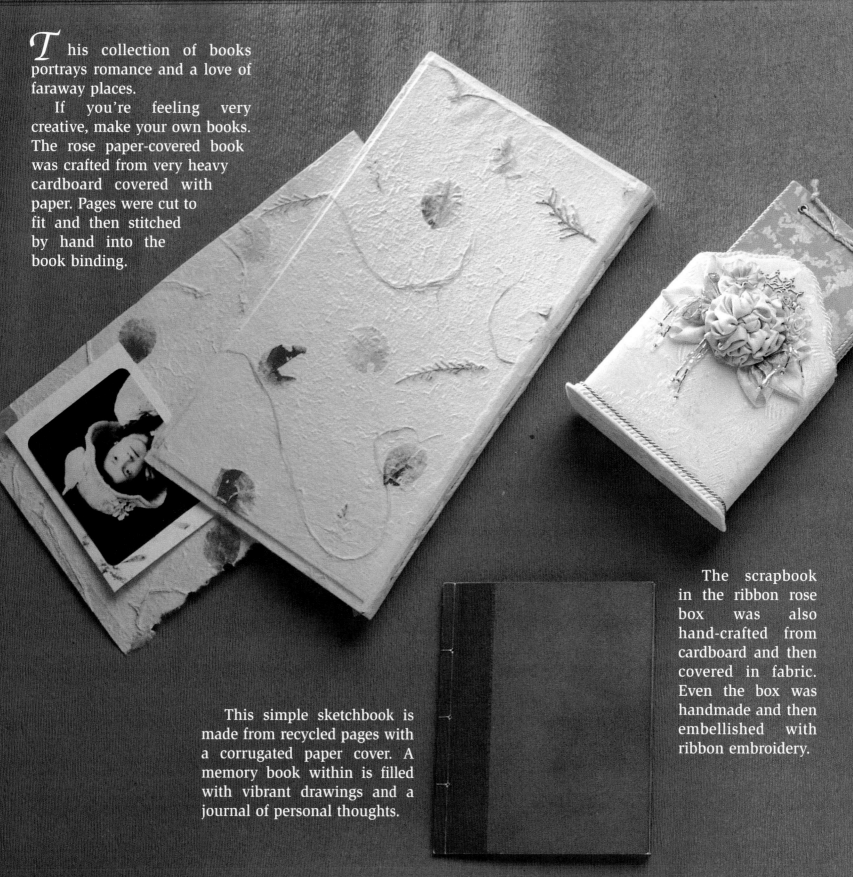

*T*his collection of books portrays romance and a love of faraway places.

If you're feeling very creative, make your own books. The rose paper-covered book was crafted from very heavy cardboard covered with paper. Pages were cut to fit and then stitched by hand into the book binding.

This simple sketchbook is made from recycled pages with a corrugated paper cover. A memory book within is filled with vibrant drawings and a journal of personal thoughts.

The scrapbook in the ribbon rose box was also hand-crafted from cardboard and then covered in fabric. Even the box was handmade and then embellished with ribbon embroidery.

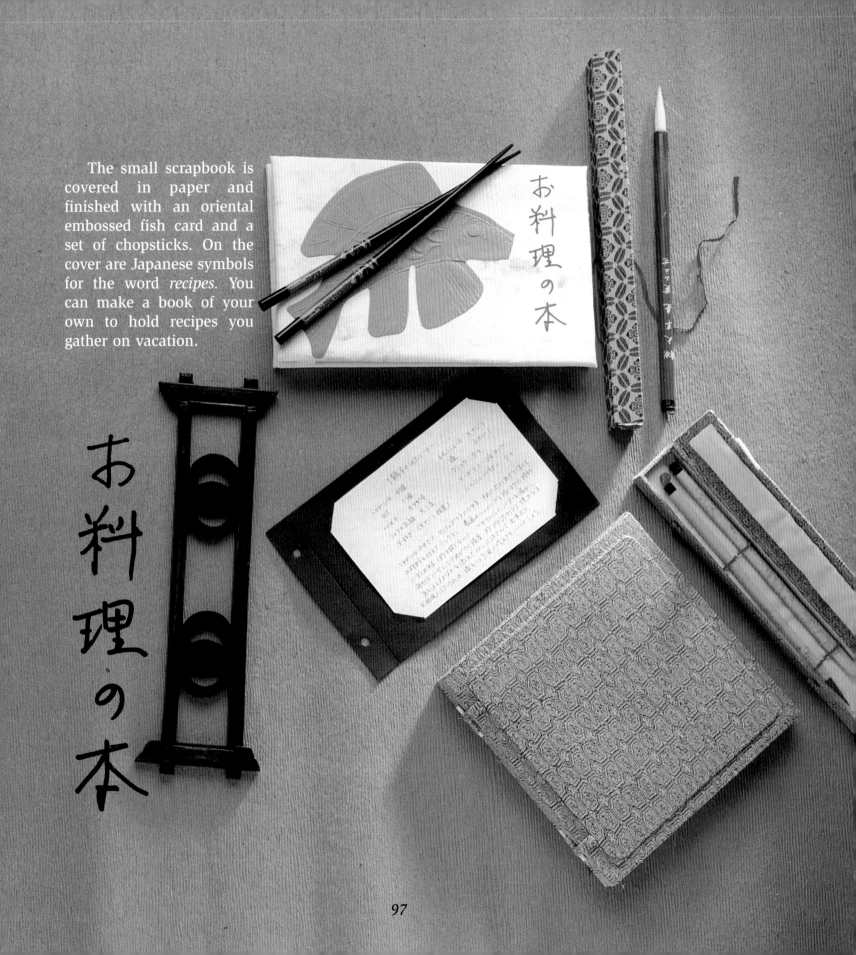

The small scrapbook is covered in paper and finished with an oriental embossed fish card and a set of chopsticks. On the cover are Japanese symbols for the word *recipes*. You can make a book of your own to hold recipes you gather on vacation.

お料理の本

お料理の本

Memory Boxes

*S*crapbooks are not the only way to organize and store memories. With a splash of creativity, you can decorate boxes with homespun charm and fill them with your most delightful photographs to create unique memory boxes. Memory boxes can hold more than just photographs. You can use them to save little treasures and fun mementos. Save antique buttons, a child's outgrown baby jewelry, or anything you cannot bear to part with.

Decorate your memory box with acrylic paints, fabrics, ribbons, buttons, charms, or decorative papers. Choose a style or theme to fit any mood you wish. Place photos loosely in boxes, or mount them first on decorative papers cut to match the shape of the box.

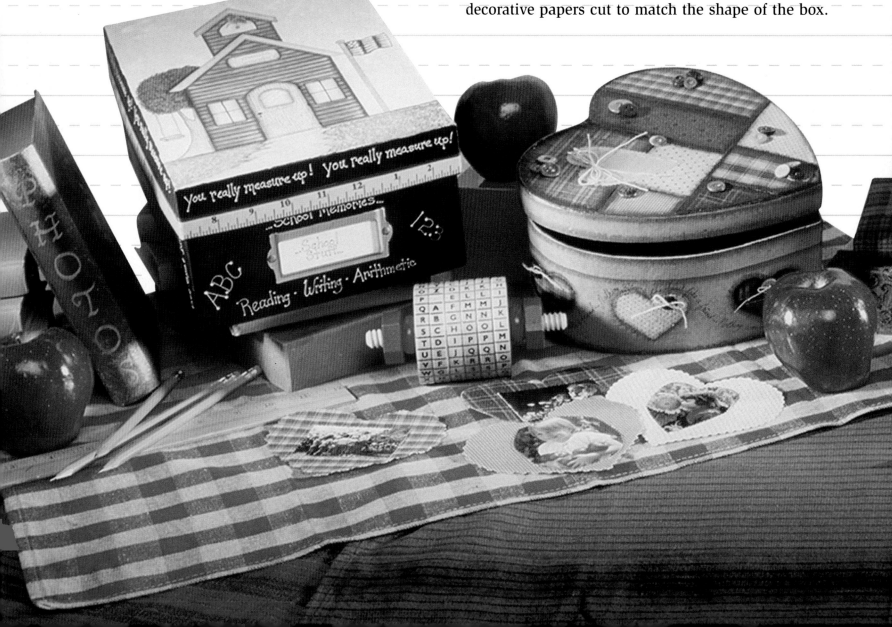

Memory boxes are great to keep and fun to give away. They make an inexpensive and treasured keepsake gift. Papier-mâché boxes, photo storage boxes, or even children's schoolboxes can all be made into memory boxes.

There are certain places I can trace to the last detail with my eyes closed; places with so many memories gathered to them, that no matter how far away I may be, they remain . . .
—Angeline Goreau

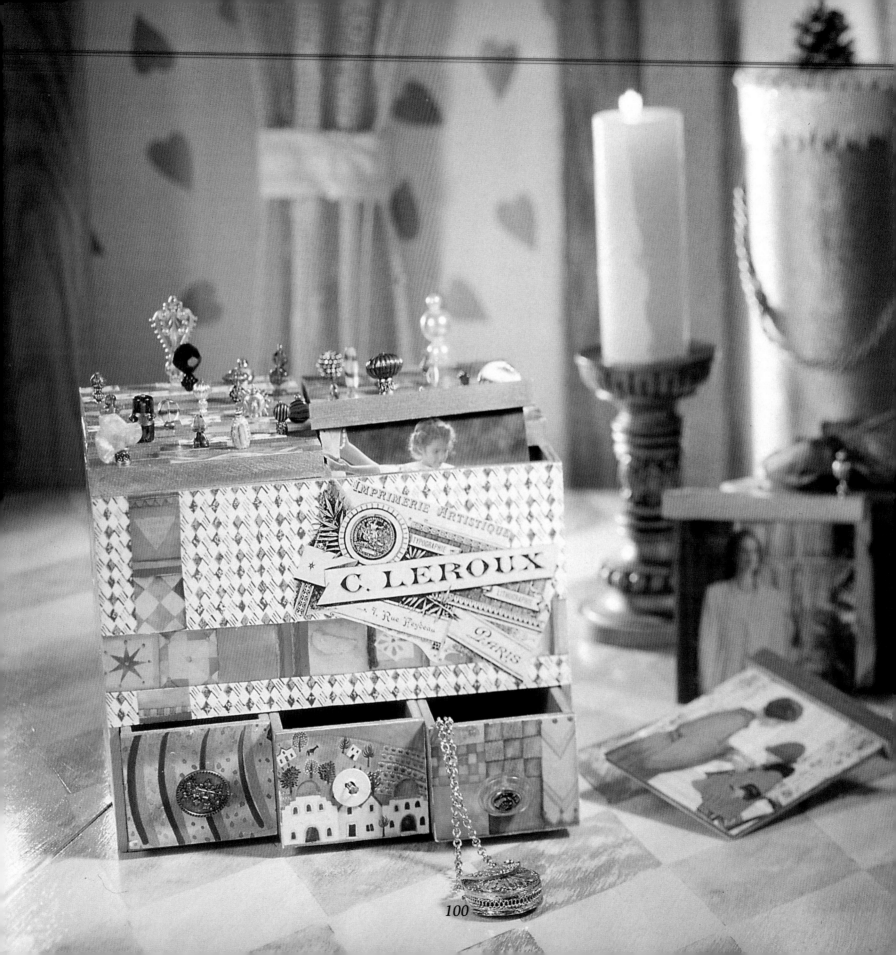

*I*f your photos and small keepsakes are a part of your life that you love to share, this eclectic photo and memento box is a perfect solution for your storage needs.

Each of the "photo slides" holds a photograph on the front and back, and each drawer has space for sweet mementos. A seashell from a beach vacation, Grandmother's locket, a tiny outgrown baby ring, or a pocket watch used by Grandfather all find a home within these drawers.

Cover the box in decorative papers to match your home, a chosen theme, or even your mood.

Photo Box

Materials:
¼"-thick birch plywood
1¼" brads
Assorted charms, beads, and buttons for photo and drawer pulls
Assorted decorative papers and labels
Découpage medium
Metallic gold spray paint
Three 1½" cotter pins
Tools: Craft glue, craft knife, dremel tool with extra small drill bit and ⅛" drill bit, jigsaw, scissors, small hammer, old ½" flat brush, pencil, and wood glue

How To:

Trace photo box pattern pieces onto plywood and cut out using a jigsaw. Assemble box as shown in diagram using wood glue. Spray two coats of metallic gold paint on inside and outside of box and drawers and both sides of photo slides. Cut decorative papers and labels as desired to fit box sides, drawer fronts, and photo slide fronts. Use a craft knife to trim away excess paper from edges. Arrange papers and labels on box, drawers, and slides and adhere in place using découpage medium. Use flat brush and more découpage medium to smooth papers and labels. When all papers and labels are adhered in place, brush a thin coat of découpage medium over all outside surfaces, making certain all edges are sealed. Let dry. Use a dremel tool and 1/8" bit to drill a hole in center of each drawer. For drawer handles, insert cotter pin through loop on back of button and push button to end of pin. Insert pin through drawer hole, then spread apart and flatten to secure. For photo slide handles, attach charms and beads with brads and small amount of glue. Use dremel tool and an extra small bit to drill holes in photo slides, if needed.

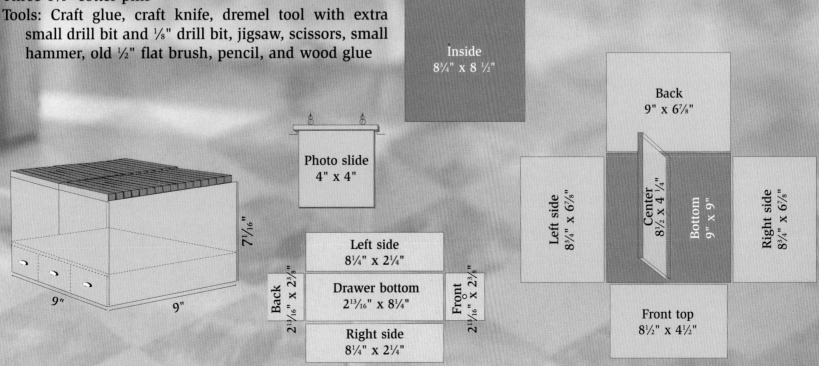

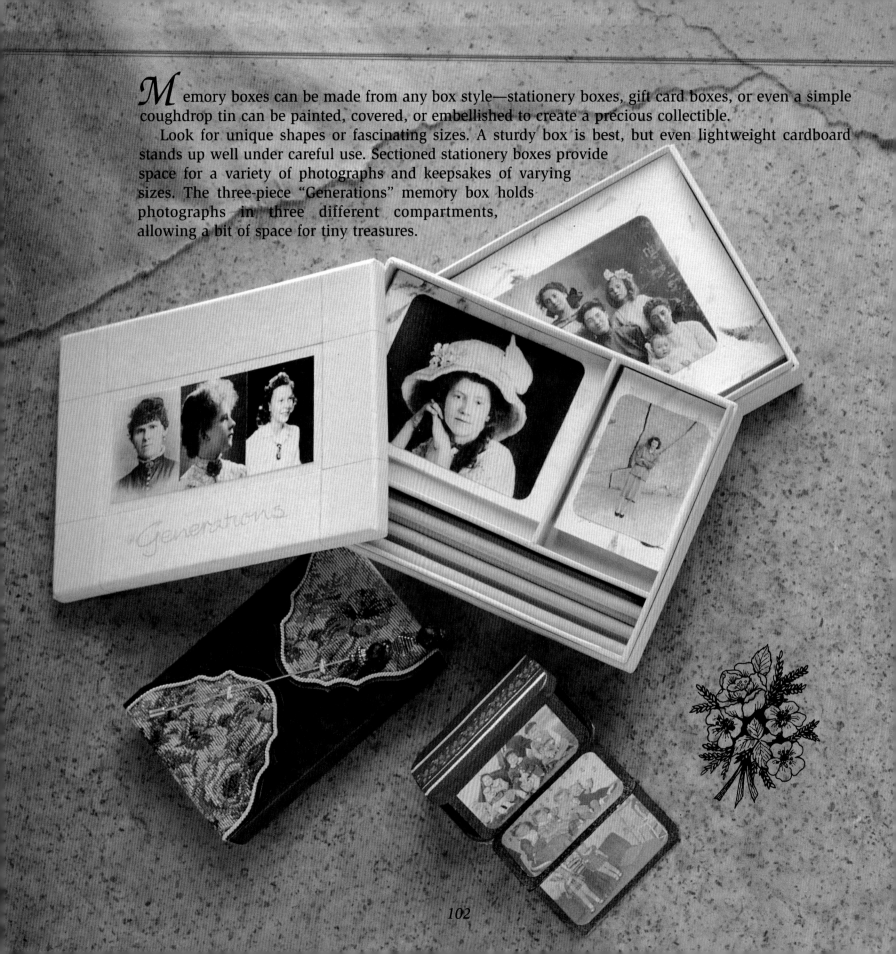

Memory boxes can be made from any box style—stationery boxes, gift card boxes, or even a simple coughdrop tin can be painted, covered, or embellished to create a precious collectible.

Look for unique shapes or fascinating sizes. A sturdy box is best, but even lightweight cardboard stands up well under careful use. Sectioned stationery boxes provide space for a variety of photographs and keepsakes of varying sizes. The three-piece "Generations" memory box holds photographs in three different compartments, allowing a bit of space for tiny treasures.

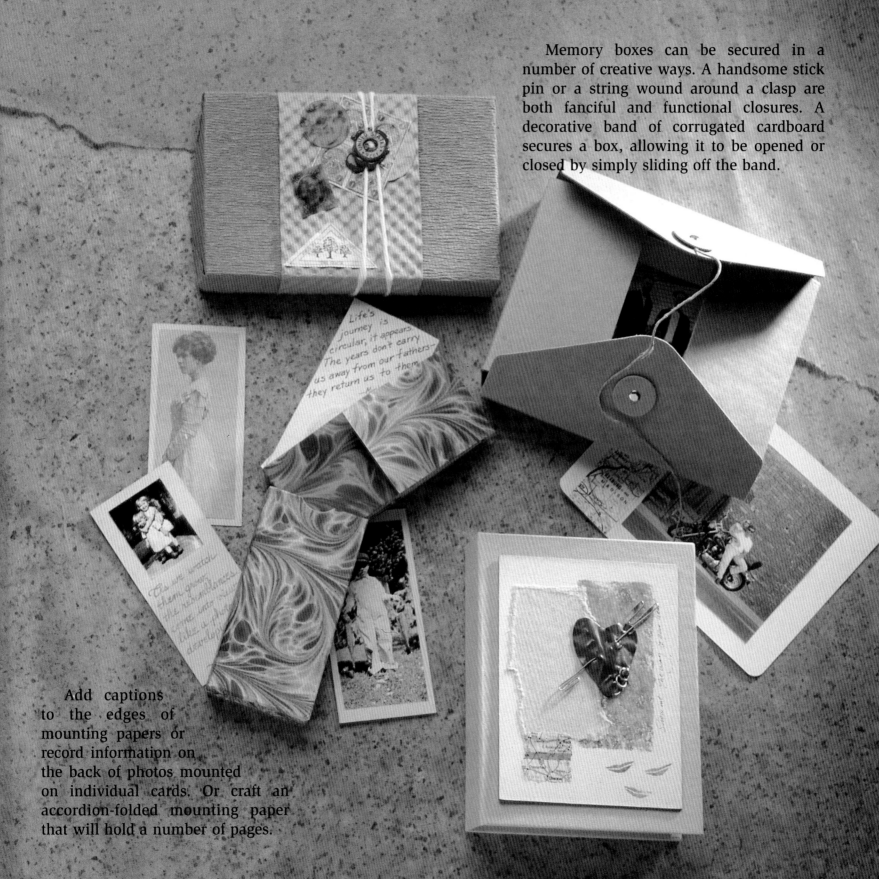

Memory boxes can be secured in a number of creative ways. A handsome stick pin or a string wound around a clasp are both fanciful and functional closures. A decorative band of corrugated cardboard secures a box, allowing it to be opened or closed by simply sliding off the band.

Add captions to the edges of mounting papers or record information on the back of photos mounted on individual cards. Or craft an accordion-folded mounting paper that will hold a number of pages.

Familiar Faces

Materials:
½" ribbon
All-purpose sealer
Cardstock
Découpage medium
Gesso
Metallic gold, ivory, and dark tan acrylic paints
Paper clay
Small face, large face, and hands push molds
Unfinished wood box with lid
Tools: craft glue, decorative corner punch and round hole paper punch, decorative-edge scissors, ½" flat brush, garlic press, old nylons, sandpaper, scissors, small sponge, talcum powder, and toothpicks

How To:
Lightly sand inside and outside of box to smooth rough edges. Wipe with an old nylon to remove dust. Apply all-purpose sealer following manufacturer's instructions. Dilute gesso with water 1:1. Brush mixture onto box and buff with extra-fine sandpaper so wood grain shows and an overall white cast is present on box. Paint inside of box ivory. Sprinkle talcum powder into molds, then gently tap to remove excess powder. Press a small piece of clay into mold. Work clay into mold, then tap upside down to release clay. Trim excess clay from around face. Enhance facial features with a toothpick. Repeat process to create desired number of faces and hands. Use a sponge brush to apply a light coat of découpage medium on box lid. Let dry. Arrange and glue faces and hands on lid. Press clay through garlic press to make hair. Twist and braid hair as desired and glue in place. Allow decorated lid to dry for two to three days. If any areas lift or cracks appear, seal with dampened clay. When lid is completely dry, apply two coats of découpage medium, allowing one coat to dry before applying next coat. Brush entire lid with a light coat of ivory paint. Let dry, then lightly stipple dark tan paint into sculpted areas of lid. Immediately buff with an old nylon. Dry-brush metallic gold paint onto high surfaces, then buff. Apply a coat of sealer to completed lid.

Cut cardstock into pages to fit inside of box. Trim edges and corners of pages with decorative-edge scissors and corner punch. Lightly sponge edges of pages with paint to create a subtle texture. Punch two holes on left side of pages, then thread ribbon through holes and tie. Glue photos and record history on pages.

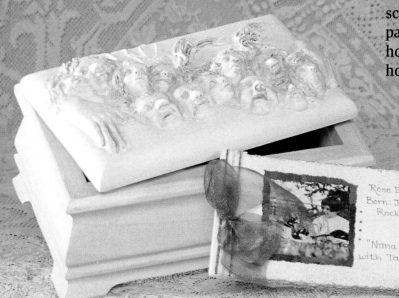

My house is filled with photographs. It's my nature to save things— hold the moment.
—Susan J. Gordon

ake each memory a "special delivery" with this classic postal box. Postage stamps and letter art make it truly unique. Put photographs in the box individually, or mount them on small cardstock sheets and bind them together. Mount this postal box on a wall or display it on a table.

Mail Box

Materials:
Antique découpage medium
Old letters, stamps, and postmarked envelopes
Wood box with chimney
Tools: ½" flat brush, craft knife, and scissors

How To:
Make color copies of old letters, stamps, and postmarked envelopes, and make a copy of "Photos" pattern on tan parchment paper at a color copy center. Cut out individual stamps and cut out copies as desired. Arrange papers on box and adhere in place using découpage medium. Glue stamps in an alternating pattern on chimney for bricks. Use a flat brush and more découpage medium to smooth papers. Use a craft knife to trim away excess paper from edges. When all papers are glued in place, brush a thin coat of découpage medium over entire outside surface.

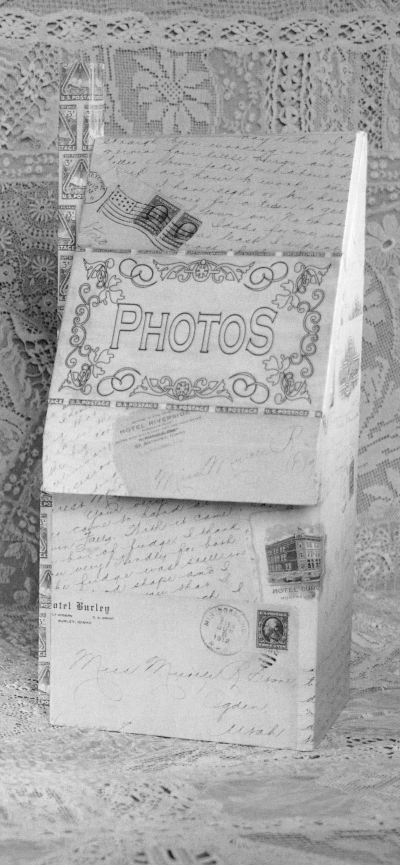

Bless this house, O Lord, we pray,
Make it safe by night and day . . .
Bless the roof and chimneys tall,
Let thy peace lie over all;
Bless this door, that it may prove
Ever open to joy and love.
—Helen Taylor

*I*f your old photos are kept in high-acid, poor-quality scrapbooks, now is the time to do something about it. Self-stick photograph albums with plastic sheet covers are the most dangerous kind of scrapbook. Get your precious photographs out of them as soon as possible.

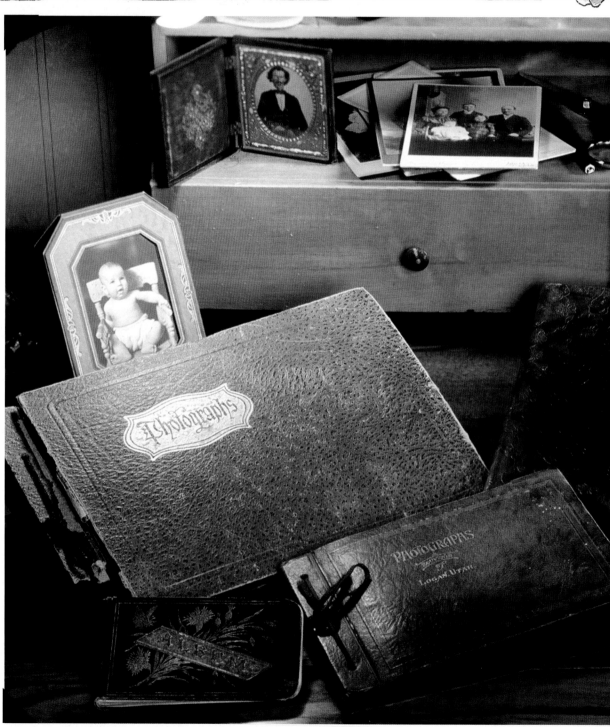

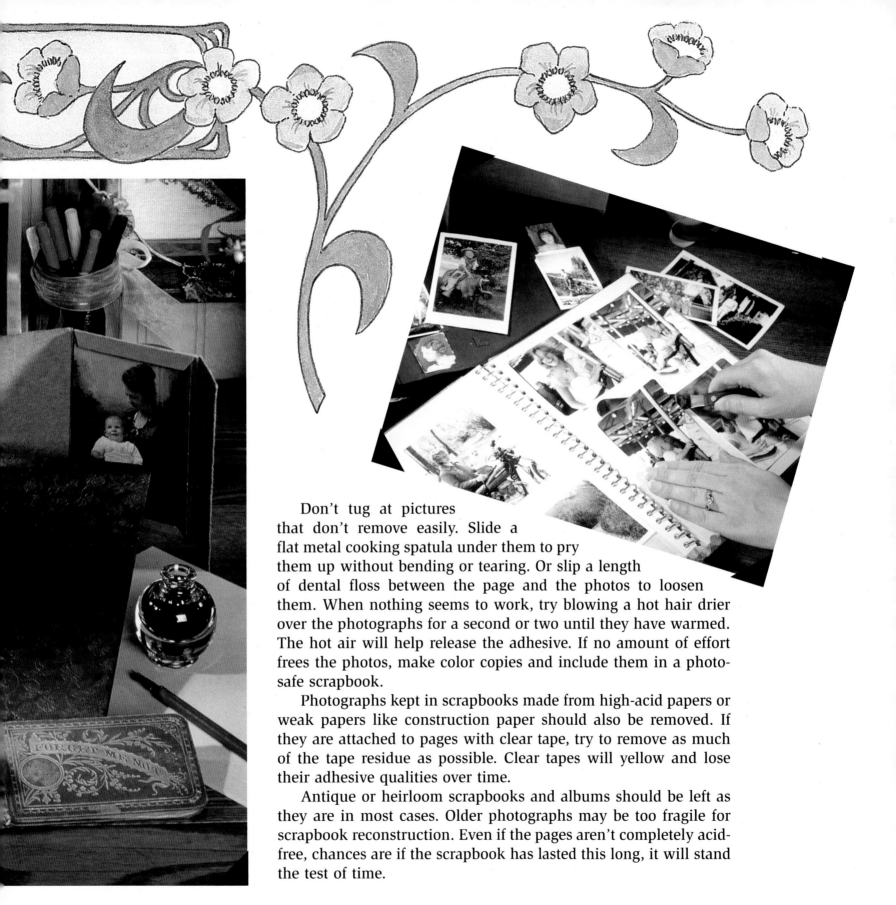

Don't tug at pictures that don't remove easily. Slide a flat metal cooking spatula under them to pry them up without bending or tearing. Or slip a length of dental floss between the page and the photos to loosen them. When nothing seems to work, try blowing a hot hair drier over the photographs for a second or two until they have warmed. The hot air will help release the adhesive. If no amount of effort frees the photos, make color copies and include them in a photo-safe scrapbook.

Photographs kept in scrapbooks made from high-acid papers or weak papers like construction paper should also be removed. If they are attached to pages with clear tape, try to remove as much of the tape residue as possible. Clear tapes will yellow and lose their adhesive qualities over time.

Antique or heirloom scrapbooks and albums should be left as they are in most cases. Older photographs may be too fragile for scrapbook reconstruction. Even if the pages aren't completely acid-free, chances are if the scrapbook has lasted this long, it will stand the test of time.

Preserving Family Records

S crapbooks are a great place to show pride in family history. An heirloom scrapbook might hold a family tree and the names and birth dates of family members who came before. If this information isn't known, a search through family and public records may turn up precious history.

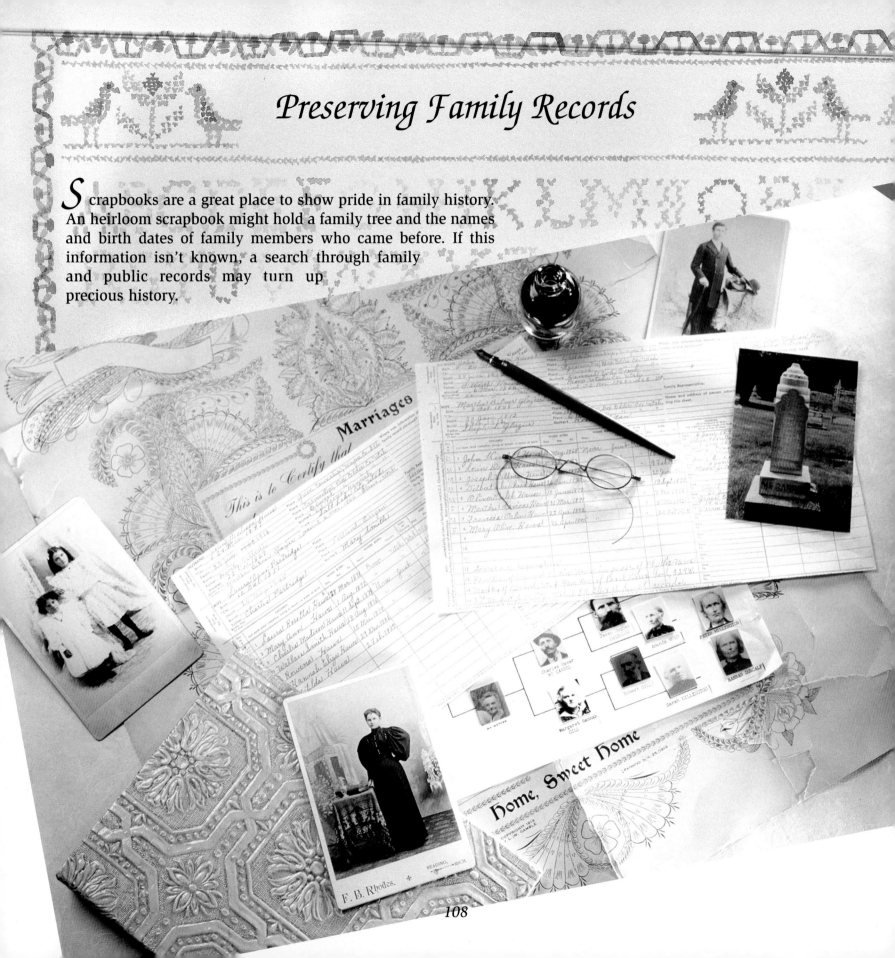

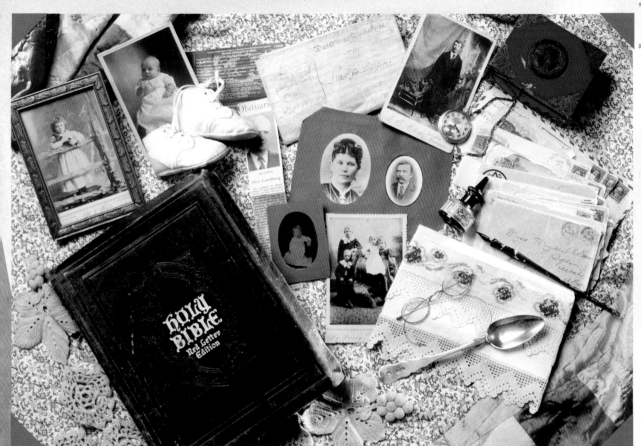

about those who came before. Names of past ancestors and information about them may be found in documents still in family possession. To find clues to the past, look for birth, marriage, and death certificates; obituaries; marriage announcements and invitations; family bibles; high school and college diplomas; old passports; needlework samplers; initialed flatware; old quilts; photographs; military discharge papers; wills; and letters. Use these to find out the names of ancestors, and their dates of birth, marriage, and death. There's more information in public documents like birth, marriage, and death certificates. These are typically found in the courthouse of the county where the event took place, and can often be obtained in person or by mail.

The best place to start in a search for family roots is at home. Record all the knowledge that you can from family members. Visit, write, or call others to see what they may know. Pay special attention to the oldest ones in your family. Their recollections are a treasure that won't always be available. Ask them as many questions as possible now, while memories are still fresh and details can be remembered.

The Next Step

Once your living family memories have been explored, look further into the past to discover more

Beyond Names and Dates

Names and birth dates are only the beginning of a family history. Each person on every family tree lived an entire life filled with family, work, love, interests, challenges, and victories. Living family members may remember some of these details, but more information about those who are now gone may be found in a

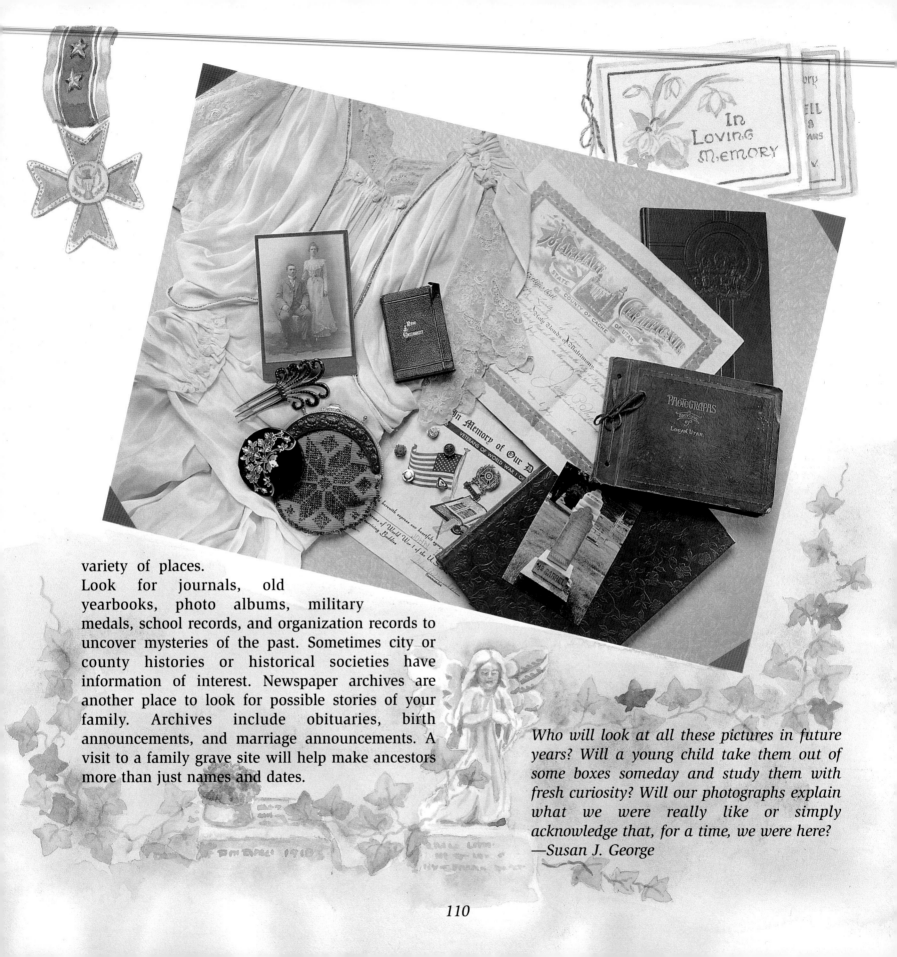

variety of places.

Look for journals, old yearbooks, photo albums, military medals, school records, and organization records to uncover mysteries of the past. Sometimes city or county histories or historical societies have information of interest. Newspaper archives are another place to look for possible stories of your family. Archives include obituaries, birth announcements, and marriage announcements. A visit to a family grave site will help make ancestors more than just names and dates.

Who will look at all these pictures in future years? Will a young child take them out of some boxes someday and study them with fresh curiosity? Will our photographs explain what we were really like or simply acknowledge that, for a time, we were here?
—Susan J. George

Clip Art

Using clip art is a simple way to add fun to scrapbook pages. Photocopy the piece of clip art that you need onto paper—enlarging or reducing to fit the size of your scrapbook. Use these designs to decorate full pages, to frame photographs, as photo corners, or to decorate the corners or edges of a page.

In addition to the clip art on the following pages, clip art and clip art books are available at local copy shops and craft stores.

Enlarge individual clip art sections or frames on this page 250 percent for an 8½ x 11-inch scrapbook page.

Enlarge individual clip art sections or frames on this page 250 percent for an 8½ x 11-inch scrapbook page.

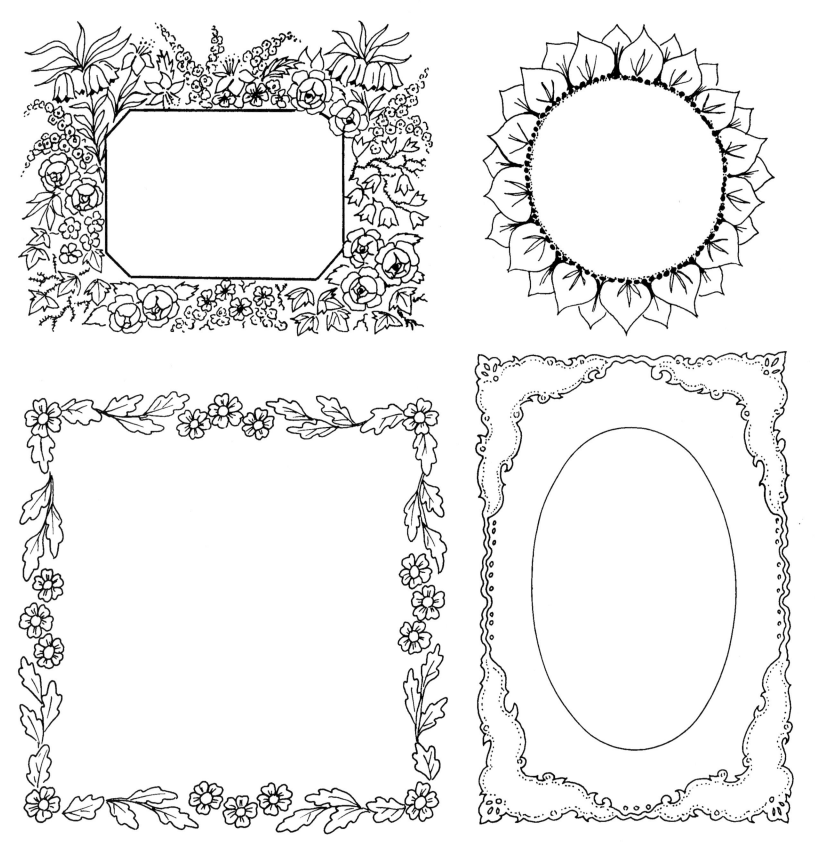

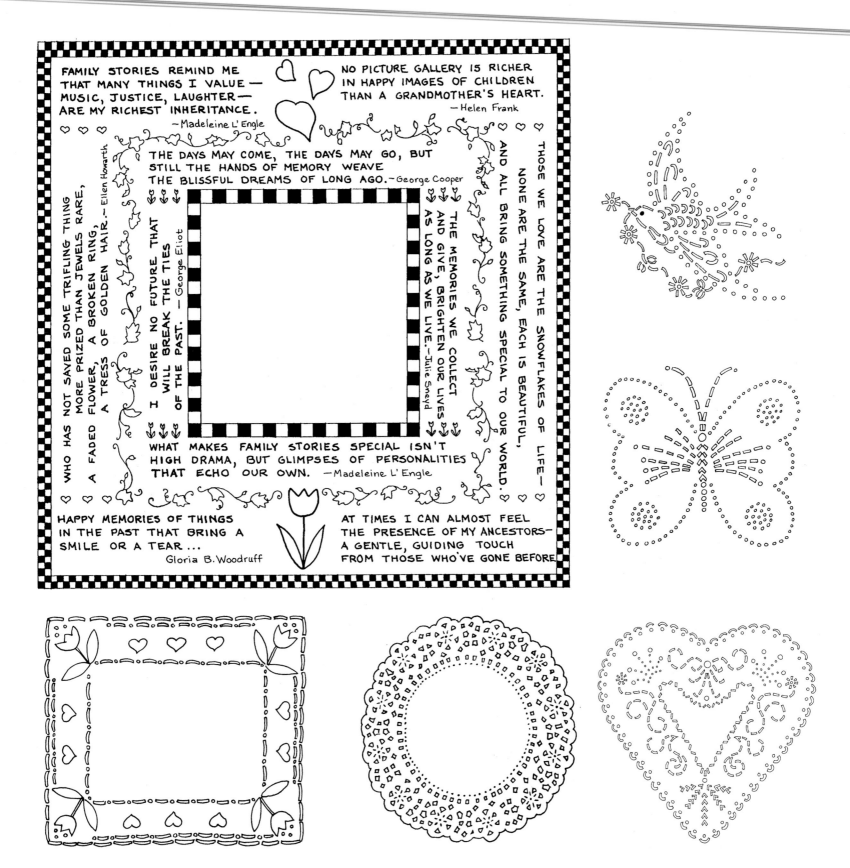

FAMILY STORIES REMIND ME
THAT MANY THINGS I VALUE —
MUSIC, JUSTICE, LAUGHTER —
ARE MY RICHEST INHERITANCE.
— Madeleine L'Engle

NO PICTURE GALLERY IS RICHER
IN HAPPY IMAGES OF CHILDREN
THAN A GRANDMOTHER'S HEART.
— Helen Frank

THE DAYS MAY COME, THE DAYS MAY GO, BUT
STILL THE HANDS OF MEMORY WEAVE
THE BLISSFUL DREAMS OF LONG AGO. — George Cooper

WHO HAS NOT SAVED SOME TRIFLING THING MORE PRIZED THAN JEWELS RARE, A FADED FLOWER, A BROKEN RING, A TRESS OF GOLDEN HAIR. — Ellen Howarth

I DESIRE NO FUTURE THAT WILL BREAK THE TIES OF THE PAST. — George Eliot

THE MEMORIES WE COLLECT AND GIVE, BRIGHTEN OUR LIVES AS LONG AS WE LIVE. — Julie Sneyd

AND ALL BRING SOMETHING SPECIAL TO OUR WORLD.

THOSE WE LOVE ARE THE SNOWFLAKES OF LIFE — NONE ARE THE SAME, EACH IS BEAUTIFUL,

WHAT MAKES FAMILY STORIES SPECIAL ISN'T
HIGH DRAMA, BUT GLIMPSES OF PERSONALITIES
THAT ECHO OUR OWN. — Madeleine L'Engle

HAPPY MEMORIES OF THINGS
IN THE PAST THAT BRING A
SMILE OR A TEAR ...
Gloria B. Woodruff

AT TIMES I CAN ALMOST FEEL
THE PRESENCE OF MY ANCESTORS —
A GENTLE, GUIDING TOUCH
FROM THOSE WHO'VE GONE BEFORE

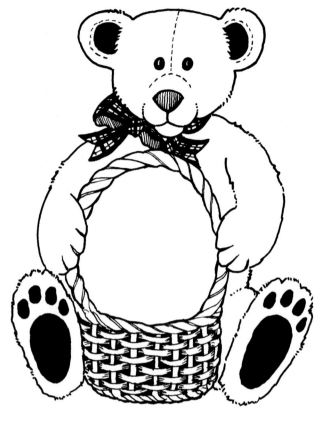
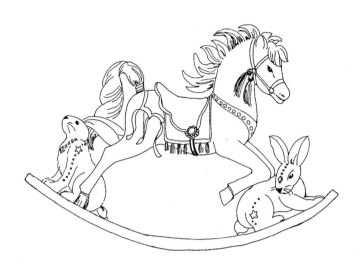

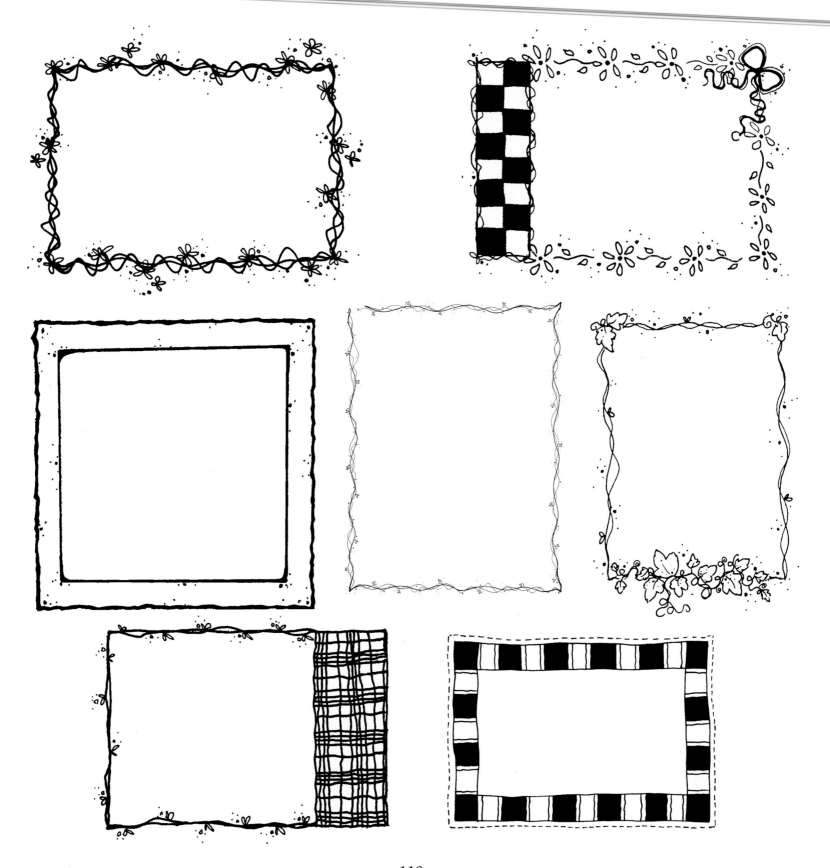

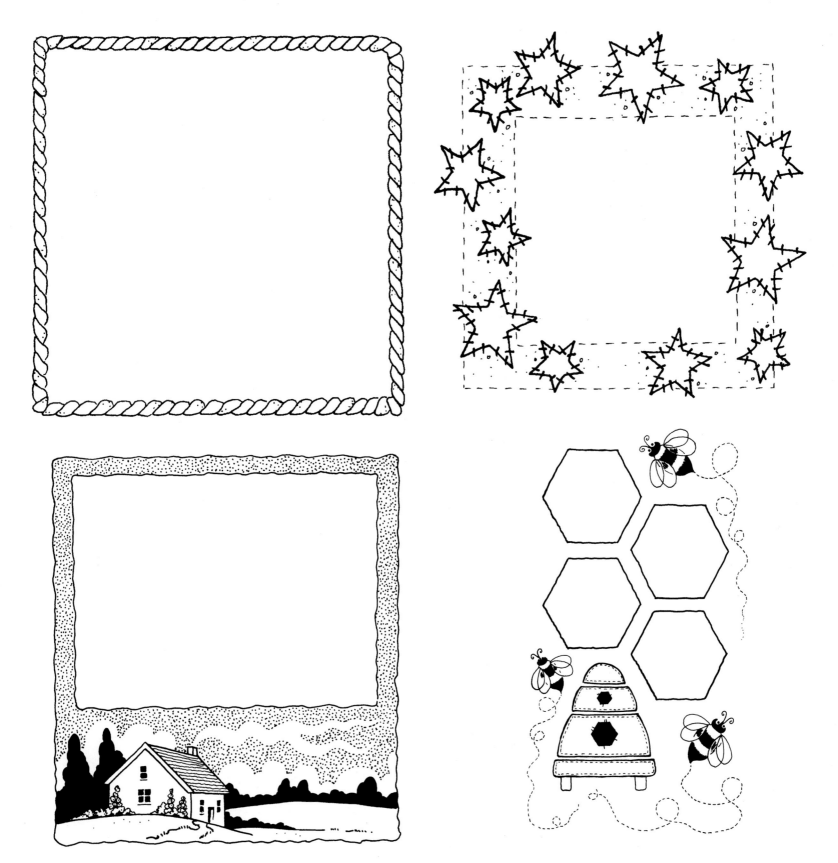

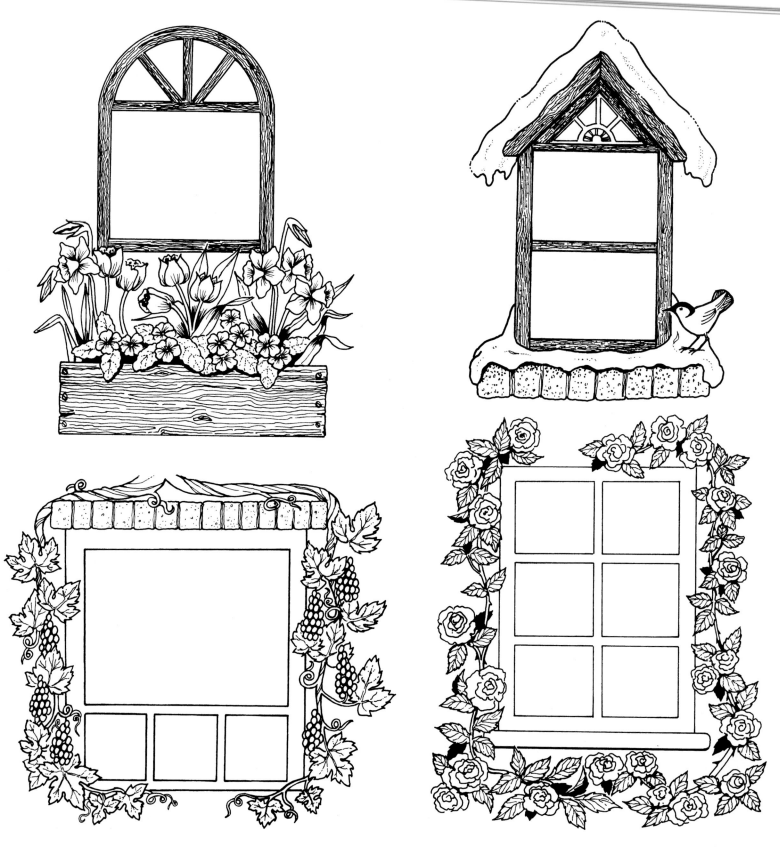

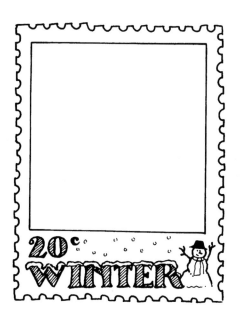

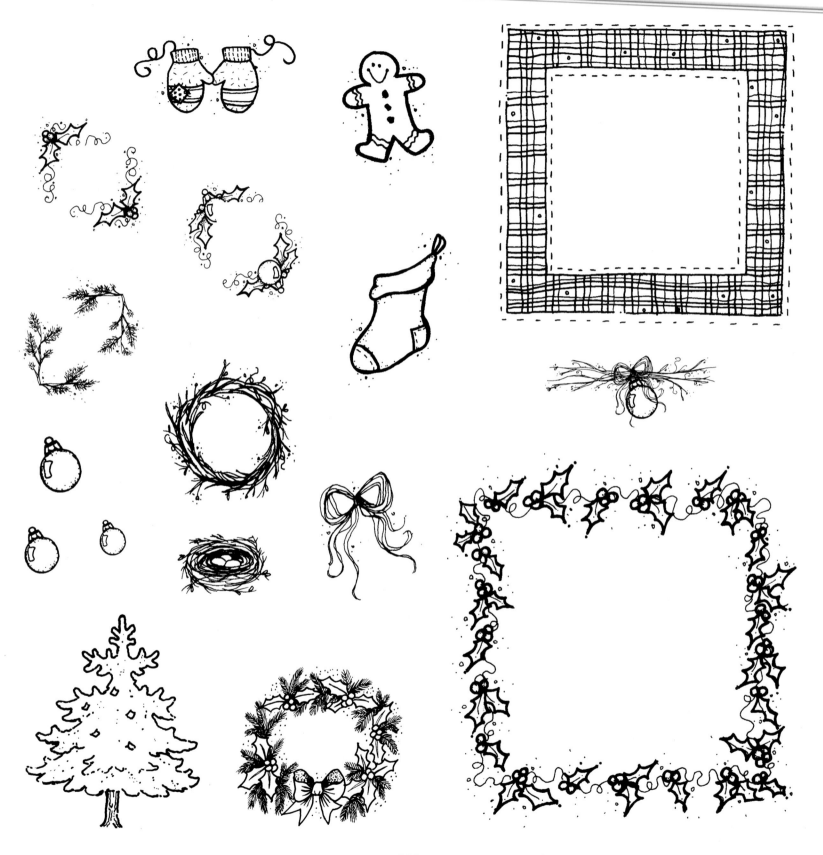

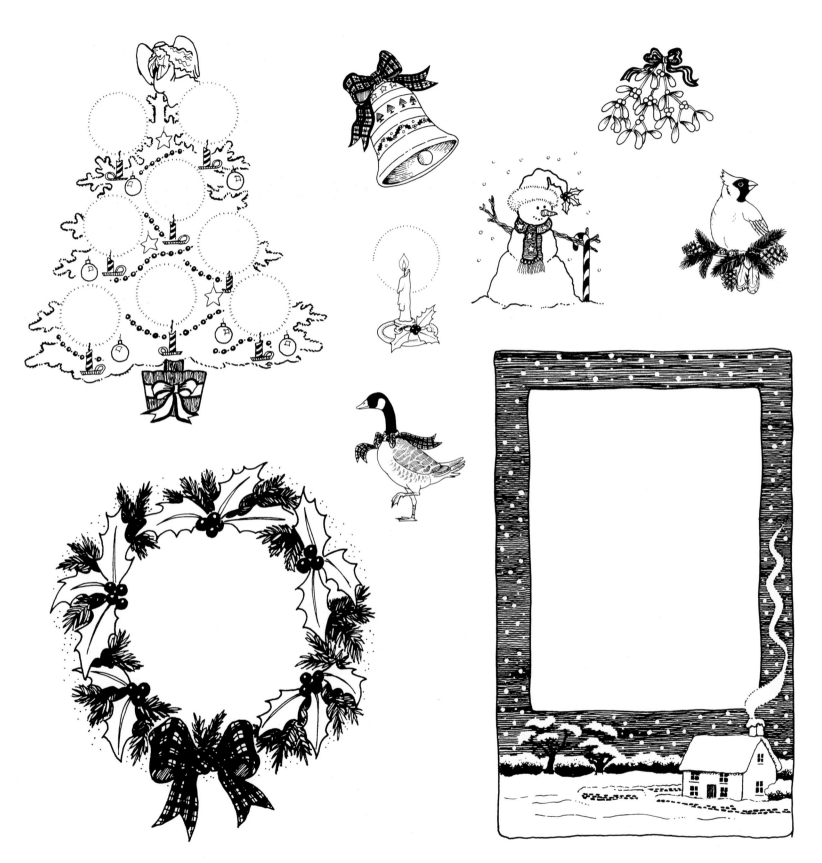

Additional Information and Sources

The following offices and addresses will be helpful for obtaining family history records:

Birth certificates, death certificates, and marriage certificates are typically kept in the town or county courthouse where the individual has lived. Requests for such can generally be made by mail to the town or county records department. In order to obtain records a small fee and self-addressed stamped envelope may be necessary.

The above records can also be obtained at the state level. A booklet entitled "Where to Write for Vital Records—Births, Deaths, Marriages, and Divorces" is available from the The Department of Health and Human Services by sending a self-addressed envelope and $2.50 to:

Superintendent of Documents
Government Printing Office
Washington, D.C. 20402-9325

The above information is also available free of charge, at the following internet address:

http://www.cdc.gov/nchsww/nchshome.htm

Most states will have specific fees for requested documents and information.

Federal records that may be of use include: census records, military pension records, passenger arrival lists, and naturalization records.

Census records can be obtained for a fee by writing to:

U.S. Department of Commerce
Bureau of the Census
Pittsburgh, Kansas 66762

Military pension records and passenger arrival lists are available through the National Archives:

National Archives and Records Service
NNC
Washington, D.C. 20408

Other sources for records are: newspaper archives, church records, grave markers, and internet web sites.

The unique, archival, ready-to-purchase scrapbooks shown in this book are manufactured by the following companies:

Books Nouveau
Bonnie Dasse
P.O. Box 955
Seaside, OR 97138
Phone (503) 738-5519
Fax (503) 738-0753

The Cornelia Collection
Elements/Jill Schwartz
126 West 22nd Street
New York, NY 10011
Phone (212) 243-2707
Fax (212) 243-1809

Molly West Handbound Books
1255A Park Avenue
Emeryville, CA 94608
Phone (510) 653-2830
Fax (510) 653-2840

Schiavone Studios
Books and Screens
3021 Vining Street
Bellingham, WA 98226
Phone/fax (360) 676-2654

The lovely printed cards in this book used to frame photographs were designed by:

Candace Pratt Hoover
Reverie Publishing Company
P.O. Box 2220
Alameda, CA 94501
Phone (510) 521-1740

Index

Additional Information and Sources127
Aged Paper ..61
Archival-Quality Scrapbooks11–13
Artist-Quality Colored Pencils25
Beyond Names and Dates109–110
Beyond Traditional Scrapbooks92–97
Blue Leaves Scrapbook Page84
Buying a Good-Quality Camera14
Catching Real Life..17
Chalk Pastels ..25
Children's scrapbooks54–55
Clip Art ..111–126
Cropping Your Photos ...19
Designing Scrapbooks—the Third Step29–31
Experiment with Angles16
Familiar Faces ..104
Faraway Places Cover ..48
Felt-Tip Markers ..25
Get in Close ..15
Gold Leaf-Imprinted Scrapbook Page80
Hand Tinting ...24–25
Introduction ...8–10
Japanese Ribbon Cover49
Leaf and Napkin Scrapbook Page79
Mail Box ..105
Manipulating Your Photos18
Memory Boxes ..98–105
Oil Pastels ..25

Organizing a Work Space27
Organizing Negatives ...28
Organizing Photographs27
Organizing—the Second Step26–28
Pastel Lace Paper Scrapbook Page82–83
Pet scrapbook pages76–77
Photo Art ...20–21
Photo Box ..101
Photo wraps ..64–69
Photographic Hand-Coloring Pens25
Photography—the First Step14–25
Preserving Old Photographs106–107
Preserving Family Records108–110
Ready-to-purchase scrapbooks34–41
Reunion Quilt ...70–71
Rose Frame Cover ..46–47
Scrapbook cover titles ..33
Scrapbook Covers33–55
Scrapbook Covers ...29
Scrapbook page titles ..57
Scrapbook Pages57–91
Scrapbook Pages ...30–31
Shooting Outdoors ..16
Storing Negatives and Photographs28
The Next Step ..109
Winter Scene Scrapbook Page87
Zooming and Cropping22–23